Phil Malpas

CAPTURING COLOUR

n. the appearance of
objects (or light sources)
described in terms of their
hue and lightness (or
brightness) and saturation.

An AVA Book

Published by AVA Publishing SA
Rue des Fontenailles 16
Case Postale
1000 Lausanne 6
Switzerland
Tel: +41 786 005 109
Email: enquiries@avabooks.ch

Distributed by Thames & Hudson (ex-North America)
181a High Holborn
London WC1V 7QX
United Kingdom
Tel: +44 20 7845 5000
Fax: +44 20 7845 5055
Email: sales@thameshudson.co.uk
www.thamesandhudson.com

Distributed in the USA and Canada by:
Watson-Guptill Publications
770 Broadway
New York, New York 10003
Fax: + 1 646 654 5487
Email: info@watsonguptill.com
www.watsonguptill.com

English Language Support Office
AVA Publishing (UK) Ltd.
Tel: +44 1903 204 455
Email: enquiries@avabooks.co.uk

ISBN 2-940373-06-X and 978-2-940373-06-2

10 9 8 7 6 5 4 3 2 1

Design by Gavin Ambrose (gavinambrose.co.uk)
Illustrations by Amy Morgan

Production by AVA Book Production Pte. Ltd., Singapore
Tel: +65 6334 8173
Fax: +65 6259 9830
Email: production@avabooks.com.sg

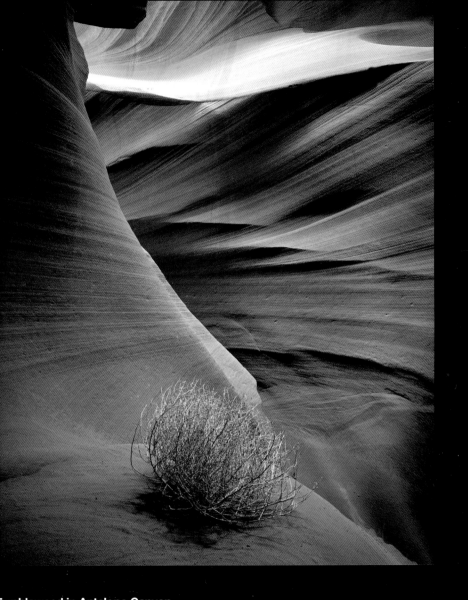

Tumbleweed in Antelope Canyon

When photographing Lower Antelope Canyon, it is important to avoid any direct light, and to construct a composition where only reflected light is present. This reduces the contrast range and allows the film to capture all the colour.

Photographer: Phil Malpas.

Technical summary: Ebony SV45TE 4x5 field camera, with Schneider Apo-Symmar 150mm f5.6 lens, exposure 5 seconds at F32, Fuji Velvia 50 rated at ISO 50, no filtration.

Contents ▷

How to get the most out of this book 6
Introduction 8

 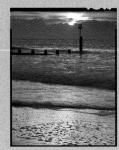 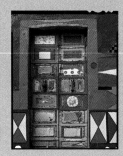

Colour theory 10
The colour wheel 12
Primary, secondary and
tertiary colours 14
Complementary colours 16
Colour harmony 18
Additive colour 20
Subtractive colour 22
Examples 24

Light 50
The electromagnetic spectrum 52
Colour temperature 54
Infrared 62

Vision 30
The human eye 32
Colour constancy
and metamerism 34
Colour blindness 36
Psychological influences 38
Cultural influences 44

Photographic colour 70
Colour films 72
Daylight and tungsten balance 76
Digital colour 78

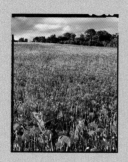 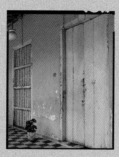

Filtration	82
Filter systems	84
The Kodak Wratten series	86
Mired and mired shift	88
Colour temperature filters	92
Neutral density filters	96
Polarising filters	102
Artificial light	108

Processing and printing	134
Using RAW files and RAW conversion	136
Adobe Photoshop	142
Toned monochrome	150
Colour management	154
Digital printing	156

Using colour	112
Limiting the colour palette	114
Colour for impact	120
Colour and emotion	124
Colour and time	130

Colour captured	160
William Lesch	162
Joe Cornish	164
Wilson Tsoi	166
Sue Bishop	168
Steve McCurry	169

Conclusion	170
Glossary	172
Acknowledgements, contacts and credits	176

This book features dedicated chapters that explain how to successfully use colour in photography. An initial analysis of classical colour theory leads to an examination of the differences between human vision and photosensitive materials. Later chapters examine how colour is reproduced photographically and the tools we can use to control its reproduction accurately. Finally a review of the techniques required to successfully control colour at the printing stage is included.

Main chapter pages
These offer a précis of the basic concepts that will be discussed.

Headings
Headings run throughout each chapter to provide a clear visual indication of your current location.

Introductions
Special chapter introductions outline basic concepts that will be discussed.

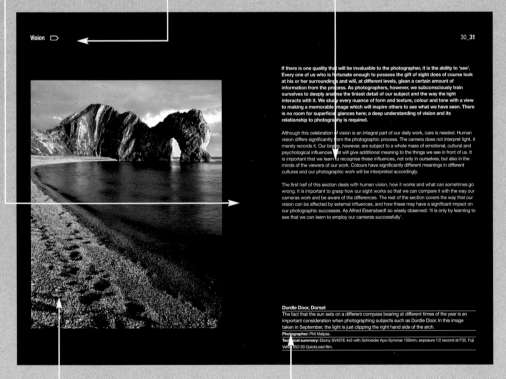

Vision ⟶ 30_31

If there is one quality that will be invaluable to the photographer, it is the ability to 'see'. Every one of us who is fortunate enough to possess the gift of sight does of course look at his or her surroundings and will, at different levels, glean a certain amount of information from the process. As photographers, however, we subconsciously train ourselves to deeply analyse the tiniest detail of our subject and the way the light interacts with it. We study every nuance of form and texture, colour and tone with a view to making a memorable image which will inspire others to see what we have seen. There is no room for superficial glances here; a deep understanding of vision and its relationship to photography is required.

Although this celebration of vision is an integral part of our daily work, care is needed. Human vision differs significantly from the photographic process. The camera does not interpret light, it merely records it. Our brains, however, are subject to a whole mass of emotional, cultural and psychological influences that will give additional meaning to the things we see in front of us. It is important that we learn to recognise these influences, not only in ourselves, but also in the minds of the viewers of our work. Colours have significantly different meanings in different cultures and our photographic work will be interpreted accordingly.

The first half of this section deals with human vision, how it works and what can sometimes go wrong. It is important to grasp how our sight works so that we can compare it with the way our cameras work and be aware of the differences. The rest of the section covers the way that our vision can be affected by external influences, and how these may have a significant impact on our photographic successes. As Alfred Eisenstaedt so wisely observed: 'It is only by learning to see that we can learn to employ our cameras successfully'.

Durdle Door, Dorset
The fact that the sun sets on a different compass bearing at different times of the year is an important consideration when photographing subjects such as Durdle Door. In this image taken in September, the light is just clipping the right hand side of the arch.
Photographer: Phil Malpas.
Technical summary: Ebony SV45TE 4x5 with Schneider Apo-Symmar 150mm, exposure 1/2 second at F32, Fuji Velvia ISO 50 QuickLoad film.

Introductory images
Introductory images give a visual indication of the context for each chapter.

Image captions
Captions call attention to particular concepts covered in the text and almost always list equipment used, exposure details and any other relevant technical information.

Quotations

The pertinent thoughts and comments of famous photographers, artists, philosophers and photographic commentators.

Images

All the images have been carefully chosen to illustrate the principles under discussion.

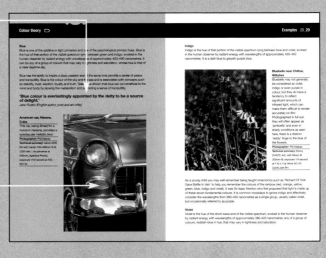

Colour theory ▷

Examples 28_29

Blue
Blue is one of the additive or light primaries and one of the psychological primary hues. Blue is the hue of that portion of the visible spectrum lying between green and indigo, evoked in the human observer by radiant energy with wavelengths of approximately 420–490 nanometres. It can be any of a group of colours that may vary in lightness and saturation, whose hue is that of a clear daytime sky.

Blue has the ability to inspire a deep passion and at the same time provide a sense of peace and tranquillity. Blue is the colour of the sky and the sea and is associated with concepts such as stability, trust, wisdom, loyalty and truth. Tests have shown that blue can be beneficial to the mind and body by slowing the metabolism and promoting a sense of tranquillity.

'Blue colour is everlastingly appointed by the deity to be a source of delight.'
John Ruskin (English writer, poet and art critic)

American car, Havana, Cuba
This car, being filmed for a movie in Havana, provides a spectacular metallic blue
Photographer: Phil Malpas
Technical summary: Canon EOS 5D with 24–105mm f/4 IS USM with 1.4x converter at 500mm, Aperture Priority, exposure 1/12 second at f22, ISO 50.

Indigo
Indigo is the hue of that portion of the visible spectrum lying between blue and violet, evoked in the human observer by radiant energy with wavelengths of approximately 420–450 nanometres. It is a dark blue to greyish purple blue.

Bluebells near Chitfoe, Wiltshire
Bluebells may not generally be considered as violet, indigo or even purple in colour, but they do have a tendency to reflect significant amounts of infrared light, which can make them difficult to render accurately on film. Photographed in full sun they will often appear as 'pinkbells' and even in shady conditions as seen here, there is a distinct 'reddy' tinge to the blue of the flowers.
Photographer: Phil Malpas
Technical summary: Ebony SV45TE 4x5, with Nikkor M 300mm f9, exposure 1/4 second at f16.5, Fuji Velvia ISO 50 QuickLoad film.

As a young child you may well remember being taught mnemonics such as 'Richard Of York Gave Battle In Vain' to help you remember the colours of the rainbow red, orange, yellow, green, blue, indigo and violet. It was Sir Isaac Newton who first proposed that it is made up of these seven fundamental colours. It is common nowadays to ignore indigo and effectively consider the wavelengths from 380–450 nanometres as a single group, usually called violet, but occasionally referred to as purple.

Violet
Violet is the hue of the short-wave end of the visible spectrum, evoked in the human observer by radiant energy with wavelengths of approximately 380–420 nanometres; any of a group of colours, reddish-blue in hue, that may vary in lightness and saturation.

Vision ▷

The human eye 32_33

The human eye

It is easy to think of vision as being the sole responsibility of the eyes, yet more correctly we should acknowledge that the eyes are simply an outpost of the brain and that we actually see with our brains. Our brains construct a complex picture of the world around us with remarkably little input from the senses. Much of our awareness is interpolated, based on knowledge, and experience and mistakes can occasionally be made.

A cross section of the human eye

[diagram of the human eye with labels: Ciliary Body, Cornea, Lens, Iris, Aqueous Chamber, Iris, Conjunctiva, Vitreous Cavity, Retina, Optic Nerve, Sclera]

The human eye is a miracle of evolution, far more capable than any mechanical camera we have been able to devise, particularly in such a compact device. When our eyes are fully adapted to current conditions (comparing night vision and bright snow conditions for example) we are able to distinguish almost 27 stops of dynamic range; that's a ratio of almost 1,000,000,000 to 1. Even under normal conditions the contrast range we can resolve is about 30,000 to 1 or 15 stops.

The main components of the eye are contained within the **sclera**, which is responsible for maintaining the eye's shape and is the anchor for the muscles that control movement. At the front of the eye are the **cornea**, **iris** and **lens**, which serve to focus the outside world on to the **retina** at the rear. The iris is an adjustable diaphragm much like the aperture ring in our cameras, which changes the size of the pupil to adjust the amount of light that can enter.

In bright conditions the pupil will be small and when it is dark it will be large. In order to focus objects at different distances on to the retina, the lens changes shape so quickly that the action is almost imperceptible to us. It is problems with the lens, particularly later in life, that often lead to farsightedness, which is caused by the lens settling into a fixed position. Luckily these problems are easily corrected by the addition of a corrective lens in the form of glasses or contact lenses in front of the eye.

The retina is a multilayered, extremely complex membrane that contains millions of light sensitive cells that detect the light entering the eye and convert it to a series of tiny electrical charges. The cells in the retina are of two main types, which are commonly known as **rods** and **cones**, and are connected through a complex series of specialised cells to the optic nerve for onward transmission to the brain.

Rods and cones have very different functions. There are about 130 million rods and between six and seven million cones in each eye. The rods are about 1,000 times more sensitive than the cones, but they only collect information in black and white. The cones are concentrated near to the optical centre of the retina and need strong light to function. It is the cones that are sensitive to colour, with each cell containing a pigment that absorbs particular wavelengths, making them sensitive to red, green or blue (actually their sensitivity peaks at about 430, 535 and 590 nanometres). The rods work better in low light and are at a greater concentration away from the optical centre. It is the rods that are responsible for our peripheral vision and, being sensitive only to black and white, they are excellent at picking up movement. This is why we often catch movement out of the corner of the eye.

The human eye

Remarkably the input from over 250 million cells, the conversion of RGB data into the full colour spectrum, the assessment of contrast, depth and spatial positioning all take place over 500 times per second, with impulses travelling through the optic nerves at over 300 miles per hour.

cones cells in the retina that only capture colour information
cornea the transparent covering at the front of the eye that protects the iris and lens
iris the human equivalent of the aperture that controls brightness and gives the eye its colour
lens the component of the eye that focuses incoming light rays on to the retina
retina the rear interior surface of the eye that holds the rod and cone cells and connects to the optic nerve
rods cells in the retina that only capture contrast (or black and white) information
sclera the membrane that contains the eye and maintains it shapes whilst acting as an anchor for the various muscles that control eye movement

Diagrams

Diagrams explain technical concepts clearly and concisely.

Running glossary

A running glossary is included where each initial use of a technical term or phrase is explained at the point where it first appears.

Introduction

For almost 100 years the domain of the photographer was an exclusively monochrome one. Successful images exploited form, texture and tone, where contrast was accurately controlled through a combination of exposure and development to ensure a full range of values from black to white in the final print.

With the invention of colour photography in the first half of the last century, everything changed. Colour films had a far smaller dynamic range with little opportunity to use exposure and development as tools to control contrast. Contrast became the enemy as over or under exposure simply led to loss of saturation and a failure to capture colour in all its glory. Texture and tone were replaced as key compositional tools by colour itself and the balance of an image relied on the colour of its component parts. Even today, with the latest film emulsions, a full understanding of how to control the use of colour is vital if successful images are to be made. The advent of digital imaging has led to a deep analysis of the true meaning of colour and how to define specific tones, hues and degrees of saturation.

This book gives students a comprehensive introduction to the subject of colour and how to master its use in the image making process. The topics discussed range from basic colour theory to the colour temperature of light and how to use colour to maximise the impact of compositions. The book teaches how to successfully predict how film will react in different conditions, and how to use filters to deal with a variety of lighting situations. It also provides guidance on how to tighten compositions by minimising the colour palette and reveals alternative approaches such as false colour infrared.

Colour theory
It is important to develop an understanding of how relationships between colours can be exploited. A theoretical approach provides a solid basis to analyse why some results are successful and others fail.

Vision
The way we see things differs greatly from the way that photographic media will record them. A good understanding of how human vision works will help in predicting photographic results more accurately.

Light
As photographers we must become intimate with light. We must appreciate all its properties and learn how to use them to convey mood and emotion. The colour temperature of the light source is of primary importance.

Photographic colour
From film to digital, photographic colours are created in various ways. In order to ensure consistency we need to appreciate the various standards for defining colours and how our cameras reproduce them.

Filtration
The three main uses for filtration are to manage contrast, balance the colour of the light source to the colour our media expects and to deal with partially polarised light sources.

Using colour
In the digital age a major component of the creative process occurs post-production where an immense variety of options are available for manipulating colour.

Processing and printing
By controlling colour we can use it to generate impact, mood and emotion as well as providing a sense of time and place. For many the colour print is the final stage in a long creative process. Control of colour at this stage is vital if our creative vision is to be fully realised.

Colour captured
A collection of work by some of the world's greatest photographers and an appreciation of how they have used colour to create their most powerful images.

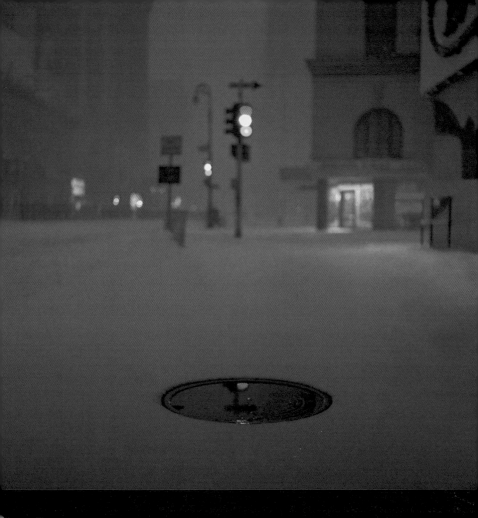

Times Square

The ability to choose appropriate filtration to enhance the mood of an image is a skill we all need to practise if we are to produce stunning images such as this wonderfully cold, moody view of Times Square.

Photographer: Pete Turner.

Technical summary: Rolleiflex 6x6 with 50mm lens, exposure 10 seconds at F5.6, ISO 25, CC50 blue filter.

The prime objective of this book is to provide photographers with tools and techniques that will lead to more successful photographic images. Any analysis of the success or failure of an image can only ever be a subjective one, entirely dependent on the opinion of the viewer. There are, however, ways to maximise the potential for success by following certain guidelines with regard to the colours you include in your compositions.

Over the millennia, the human race has evolved certain generic responses to colours and their relationships. A full understanding of these responses and the application of this knowledge in your photography will ensure that your work will appeal to the largest possible audience.

In this section you will learn about the relationships between colours and how these might be interpreted by the viewer. Colours can be used in isolation, in combination, or in multiples to different effects. These combinations can, by intention, result in harmony or discord in your images.

It is important that you understand how colours are created, either by addition or subtraction, as well as associations that are often made with various colours and what exactly they might imply to your viewer. To many of us such an understanding comes completely naturally, but it is worth examining why our instinctive choices occur in order to improve our chances of repeating our successes.

The concepts covered in this section will be second nature to graphic designers, sales executives and marketing professionals who are formally trained to appreciate how their colour choices can directly affect the bottom line. As successful photographers we are also in the business of producing, marketing and selling our work, and exactly the same concepts apply.

You should view this section as the start of a wonderful relationship with colour, an aid to developing an intimate understanding of it and a thoughtful approach to photography as, in the words of John Ruskin: 'The purest and most thoughtful minds are those which love colour the most'.

Rock detail near Horseshoe Bend Overlook, Arizona
It can be interesting to remove all reference from your composition that might give a sense of scale. This image could be a tiny detail or a huge fantasy, alien landscape. The choice is entirely the viewer's to make.

Photographer: Phil Malpas.

Technical summary: Ebony SV45TE 4x5, with Schneider Super-Angulon 90mm f8, exposure 2.5 seconds at F32, Fuji Velvia ISO 50 QuickLoad film.

The colour wheel

Throughout history, attempts have been made to ascertain how colours are created, and what happens when various colours are mixed. The Ancient Greeks developed theories as far back as 350 BC to describe how to create various colours, which were largely based on the fact that colours are only visible in light that is brighter than black or darker than the sun. From this they surmised that colours must be dependent on the amount of darkness or light present.

In 1704 Sir Isaac Newton challenged these beliefs when he published *Opticks* in which he demonstrated his 'colour circle' and proposed that colour is actually a fundamental property of light itself, rather than a physical property of objects emitting colour. Newton's colour circle was formed by taking the colours of the visible spectrum and wrapping them into a circle so that the red end joined the blue end. Using this device he was able to demonstrate a number of relationships between the colours we see, including the fact that mixing a small number of colours could result in white light.

The artist's colour wheel

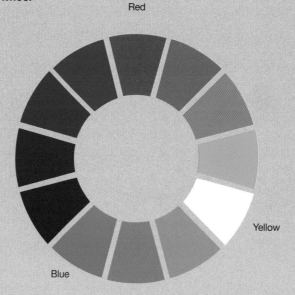

Red

Yellow

Blue

Since Newton's time, colour theorists have revised and developed **colour wheels** into the endless variety and complexity that can be found today. Generally colour wheels take two forms: those that describe the results obtained when mixing colours in the form of dyes or paints and those, like Newton's, that describe the effects of mixing light.

The artist's colour wheel is based around three fundamental or primary colours – red, yellow and blue, which are considered as such because they cannot be made by mixing other dyes, paints or pigments. This is the most common kind of colour wheel that you are likely to encounter. For our purposes, in the modern age of digital colour, we will concentrate on the RGB colour wheel, which uses red, green and blue as its basic colours from which all others are created.

The RGB colour wheel shown below contains 12 colours arranged in a circle, where each colour is created by mixing the two adjacent to it. The colours red, green and blue are used by electronic devices such as computer screens, televisions, and of course cameras, to create all the myriad colours required in full colour imagery. How this is achieved will be covered later, but for now, it is worth noting that these three colours are fundamental building blocks used in the creation of colour. By analysing the positions of all the colours on the colour wheel, it is possible to learn a great deal about colours and their relationships to each other.

The RGB colour wheel

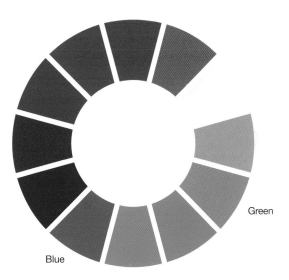

Red

Green

Blue

colour wheel a diagrammatical representation of hues in the form of a circle, such that the dominant wavelength decreases in a clockwise direction

Primary, secondary and tertiary colours

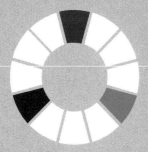

The primary colours

Red, green and blue are the building blocks that we use to create all the other colours on the RGB colour wheel. These colours are fundamental and are known as **primary colours**.

The secondary colours

Positioned between each pair of primary colours are the **secondary colours**, yellow, cyan and magenta. These colours are created by mixing equal amounts of the two primaries closest to them. For example cyan is created by mixing an equal amount of blue and green. It is also worth noting that each secondary colour does not contain any of the colour opposite it on the colour wheel. So yellow contains no blue, only red and green, and for this reason it is sometimes known as **minus blue**.

The tertiary colours

To complete the colour wheel we insert colours in the positions between the primary and secondary colours. These colours are once again created by mixing those colours adjacent to them so, for example, between red and yellow is orange, which is created by mixing red and yellow equally. Although we have a name for the mixture of red and yellow (orange) some of the other **tertiary colours** do not have their own names. Consequently it is more normal to name the tertiary colours by the colours that are used to create them. Hence we have red-yellow, green-yellow, green-cyan, blue-cyan, blue-magenta and red-magenta (where all the names take the form primary-secondary).

Hue, saturation and value

At this point it is worth noting that all the colours we have been considering here are pure colours in that they contain no white or black. The term used to describe such colours is **hue**, which can be considered as the dominant wavelength in any light source. Red, blue, green and yellow are examples of hues, whereas pink and scarlet both have the hue red.

The HSV colour model

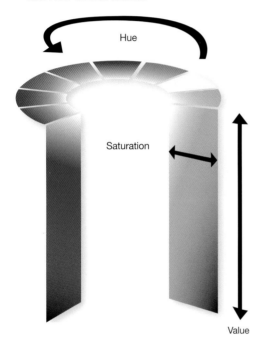

Hue

Saturation

Value

Imagine tipping the colour wheel on its side and then extending it to three dimensions, so that it forms a cylindrical shape. In the centre of the wheel on the top surface of the cylinder is white and at the centre of the bottom surface is black. Throughout the depth of the cylinder at the centre of the circles are all the infinite tones ranging from white to black. When colours are mixed with white (or made lighter) they are no longer of pure hue, and are known as **tints**. When mixed with black (or made darker) they are known as **shades**. The amount of white, black or grey that is mixed with any hue defines its **saturation** and colours near the central axis of the cylinder are desaturated. The lightness or darkness of any colour is dependent on the tonality of white, black or grey mixed with it. This tonality is known as the **value**.

By using the three measures of hue, saturation and value it is possible to precisely define any possible colour.

hue any colour, such as a red, green or blue, which is determined by the dominant wavelength of light

minus blue another description of yellow (a mixture of red and green), which contains no blue

primary colours one of the key colours that can theoretically be used to generate all other colours

saturation the vividness of a particular hue, or its difference from grey at a chosen brightness

secondary colours the complementary colours to the primary colours

shades when colours are mixed with black (or made darker) they are no longer of pure hue and are known as shades

tertiary colours there are 12 colours on the colour wheel, three are primary, three are secondary and the remaining six are tertiary

tints when colours are mixed with white (or made lighter) they are no longer of pure hue and are known as tints

value the lightness or brightness of a particular hue

Complementary colours

Now that we have defined the colour wheel, we can start to look at relationships between colours, how they interact with each other and various properties of specific sections of the colour wheel.

Complementary colours

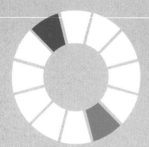

Any two colours opposite each other on the colour wheel are known as **complementary colours**. In black-and-white photography, the key compositional components are tone, texture and form. In colour photography we add to this list colour, and complementary colours provide the greatest **colour contrast**. By limiting the colours used in any composition to two complementary colours, we maximise the colour contrast, which gives greater impact to our images. It doesn't matter which two complementary colours we choose; blue and yellow, green and magenta or red and cyan, any combination of two colours on opposite sides of the colour wheel will make the colours used appear more vibrant, particularly if they are of pure hue.

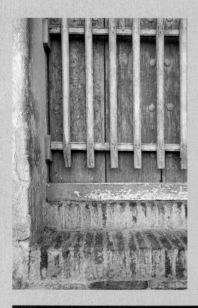

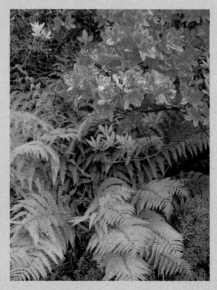

colour contrast colours on opposite sides of the colour wheel exhibit the maximum colour contrast
complementary colours any two colours that exist on opposite sides of the colour wheel
tetradic a colour scheme that utilises two sets of complementary colours
triadic a colour scheme that utilises three colours that are equally spaced around the colour wheel

Font Magica, Barcelona

Here the red and cyan coloured lighting provides intense colour contrast.

Photographer: Phil Malpas.

Technical summary: Nikon Coolpix 995 (compact) 8–32mm f2.6–5.1 zoom Nikkor at 10mm, Aperture Priority, 2 seconds at F8, ISO 100.

The triadic colour scheme

The tetradic colour scheme

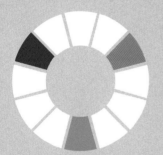

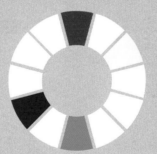

Any three colours equally spaced around the colour wheel are known as **triadic** colours. Any group of triadic colours offer us the maximum colour contrast that can be obtained from a composition limited to just three colours. The way to maximise colour contrast using four colours is to use **tetradic** colours, or two sets of complementary colours.

Doorway, Trinidad, Cuba (facing opposite, left)

Here the complementary colours are blue and yellow, but because they are tints and not of pure hue, the contrast and vibrancy effects are muted.

Photographer: Phil Malpas.

Technical summary: Canon EOS 5D with Canon 17–40mm f4.0L USM at 34mm, Aperture Priority, exposure 1/6 second at F22, ISO 50.

Rhododendrons and ferns, Westonbirt Arboretum (facing opposite, right)

This image contains pure hues of green and magenta providing maximum colour contrast. Even though the lighting was very flat and the tonal contrast is very low, the impact of the composition is provided by the colours themselves.

Photographer: Phil Malpas.

Technical summary: Nikon Coolpix 995 digital compact at 7mm focal length, exposure 1/30 second at f3.4, ISO 100, no filtration.

Colour harmony

The simplest way to maximise **colour harmony** and minimise colour contrast is to utilise colours of a single hue. By using just tints and shades of one colour we create a monochromatic colour scheme and effectively our compositional tools are restricted to those used in black-and-white photography: tone, texture and form. This approach is covered in greater depth on pages 114–133 (Limiting the colour palette).

An alternative to the monochromatic approach is to use colours that are next to each other on the colour wheel. Any group of colours that are next to each other are said to be analogous. Each colour on the colour wheel is created by mixing the two colours adjacent to it, and as such the colour contrast between **analogous colours** is at a minimum. In analogous colour schemes, it is usual for one colour to dominate and for the surrounding colours to provide highlights and enrich the overall appearance.

Analogous colours (warm)

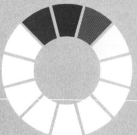

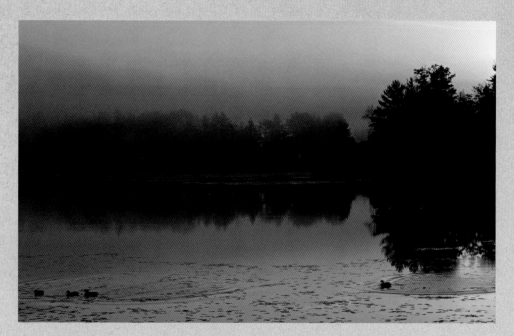

Bliss Pond, Vermont

This image taken at dawn contains only colours from the warm side of the colour wheel. Colour contrast is at a minimum and colour harmony is maximised. Using just these colours creates a calm, relaxed atmosphere.

Photographer: Phil Malpas.

Technical summary: Ebony SV45TE 4x5, with Nikkor M 300mm f9, exposure 1/4 second at F32, Fuji Velvia ISO 50 QuickLoad film, with 0.3 (one stop) soft ND Grad.

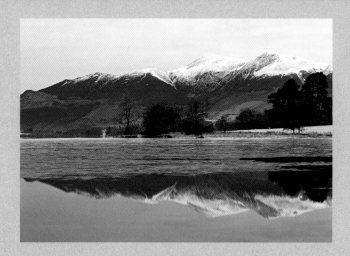

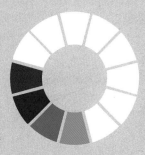

Skiddaw from Kettlewell, The Lake District

In this image only colours from the cool side of the colour wheel are present. Here you can almost feel the cold and the atmosphere is stark and foreboding.

Photographer: Phil Malpas.

Technical summary: Ebony SV45TE 4x5, with Nikkor M 300mm f9, exposure 4 seconds at F16, Fuji Velvia ISO 50 QuickLoad film.

The split complementary colour scheme

The final colour scheme we should consider is an attempt to maximise colour contrast whilst introducing a level of colour harmony.

In a **split complementary** colour scheme, a single colour is selected to dominate, then instead of contrasting it with its direct complement, we choose the colours that are analogous to that complement. In this scheme, **colour contrast** is high, but the two analogous colours also introduce a level of harmony.

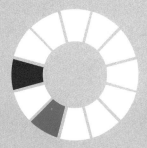

Additive colour

The modern understanding of the properties of light and colour owes a great deal to the pioneering work carried out by Sir Isaac Newton at the latter end of the 17th century. Newton showed that a prism could break white light down into its component colours, and that a further arrangement of prisms could refract the light back into its original form. In his publication *Optiks* he famously stated: 'For the rays to speak properly are not coloured', his way of saying that colour as a property is a psychological phenomenon and not a physical one.

An **additive colour system** relates to light that is emitted. It does not refer to an object that has the property red – only to a light source that is emitting red light. An additive system requires three light sources, each emitting one of the primary colours red, green and blue. If we mix two of these light sources in equal amounts, the resulting colour is one of the secondary colours cyan, yellow and magenta. When mixing equal amounts of all three light sources the result is white light.

Results of mixing additive primaries in equal amounts

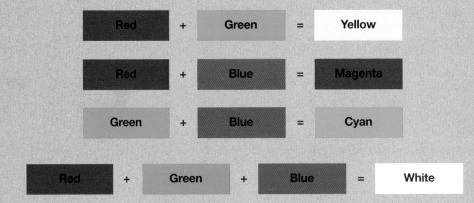

Additive colour

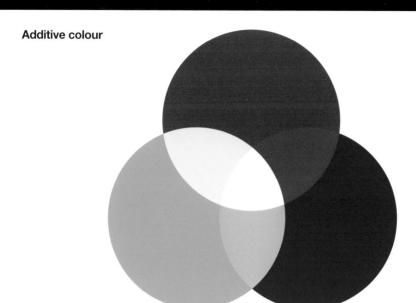

The additive colour system using coloured light sources, confirms the information provided on the colour wheel (see page 13). Yellow is made from red and green and contains no blue. It should also be clear that a mixture of red and green light in equal amounts (light of two very different wavelengths) is physically different from pure yellow light (with a single wavelength of roughly 580nm). The important thing to realise is that both stimulate our eyes and brains to give the same result that is a psychological impression that we call yellow.

The brilliant Scottish physicist James Clerk Maxwell is considered to be the founder of additive colour synthesis. In 1861 Maxwell presented to the Royal Society in London a demonstration based on ideas he had introduced at the Royal Society of Edinburgh some six years earlier. He had arranged for the photographer Thomas Sutton to photograph a tartan ribbon three times (using the available black-and-white film), each time with a different filter over the lens – red, green and blue. The three images were then projected on to the same screen and each projector lens was covered with the same colour filter used to take the original image. When the three projections were brought into register a full colour image was seen to appear.

As a footnote to Maxwell's demonstration, we now know that he was extremely lucky that it worked at all! The black-and-white film used by Sutton was only sensitive to light from the blue end of the spectrum and should not have recorded anything through the red and green filters. An attempt to repeat the experiment nearly 100 years later showed that Maxwell's green filter had in fact allowed some blue light through, and that the ribbon's red colours were reflecting ultraviolet, which was recorded with the red filter in place.

additive colour system the system that mixes red, green and blue to make all other colours

Subtractive colour

Subtractive colour theory explains how to mix inks, dyes, paints and natural colourants to create colours which absorb some wavelengths of light and reflect others. An object that absorbs one of the three primary colours from the additive world (perhaps red) will reflect the other two (green and blue) and appear to be the colour of the reflected light (in this case cyan). It follows from this that an object that absorbs cyan is effectively absorbing green and blue and will therefore reflect only red. The colour of any object viewed under white light is determined by the wavelengths of light its surface reflects and absorbs.

When viewed under a white light, a ripe banana appears yellow. This isn't because it emits yellow light (the additive world) but because it absorbs blue light and reflects only yellow. Without the white light to illuminate the banana, it would be in the dark and would appear to have no colour at all.

The primary colours of the subtractive world are cyan, magenta and yellow, so it should come as no surprise that the secondary colours are now red, green and blue. The theoretical results of mixing inks, dyes and paints in equal amounts are given in the following table:

Results of mixing subtractive primaries in equal amounts

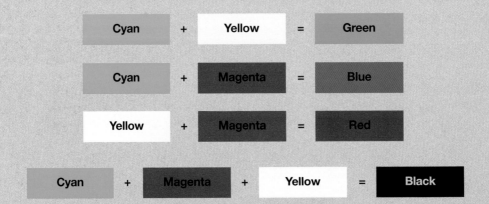

Subtractive colour

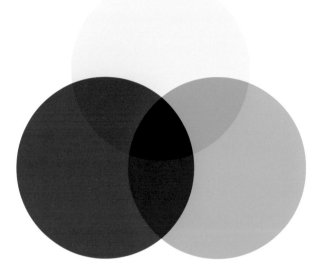

Anyone who owns an inkjet printer will be familiar with the subtractive colours as these are the ink colours used in printing processes. Cyan ink, for example, absorbs green and blue light and can therefore be used to control how much red is reflected. By altering the amount of each ink that is placed on the paper it is theoretically possible to produce almost any colour. In practice, however, impurities in the manufacture of inks mean that it is impossible to create true blacks. When mixing cyan, magenta and yellow, all that can realistically be achieved is a muddy brown. For this reason a fourth colour ink – black – is added to the process. The CMY inks are used to create the hue and the black (K) ink is used to control the value. The subtractive printing process is often referred to as CMYK after the four colour inks used in printing.

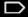

Examples

Red

Red is one of the additive or light primaries and is one of the psychological primary hues. It is the most powerful colour in our compositional armoury. Red is the hue of the long-wave end of the visible spectrum, evoked in the human observer by radiant energy with wavelengths of approximately 630–750 nanometres. It is highly visible, stands out from any background and, as Matisse noted, can often have a greater impact when it occupies a small area of the frame. Red can be any of a group of colours that may vary in lightness and saturation and whose hue resembles that of blood.

Car detail, Trinidad, Cuba
Red will always dominate an image even when it takes up a relatively small portion of the frame. This extravagantly designed rear light is a fascinating subject, but it is the fantastic red colour that initially catches the eye.
Photographer: Phil Malpas.
Technical summary: Canon EOS 10D with Canon 28–135mm f3.5–5.6 IS at 80mm, Aperture Priority, exposure 1/10 second at F18, ISO 100.

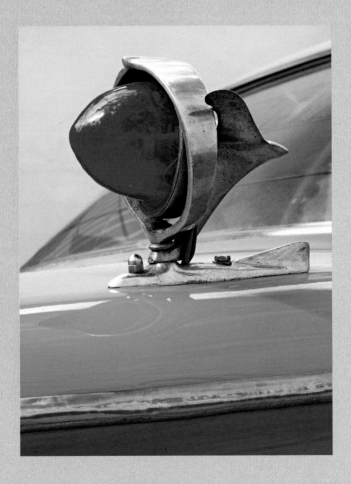

'A thimble of red is redder than a bucketful.'
Henri Matisse (influential French impressionist painter)

Orange

Orange is associated with happiness, joy and sunshine. It is the hue of that portion of the visible spectrum lying between red and yellow, evoked in the human observer by radiant energy with wavelengths of approximately 590–630 nanometres. Being a combination of red and yellow it tends to inherit the characteristics of both colours, but with slightly less intensity. Orange can be any of a group of colours between red and yellow in hue, of medium lightness and moderate saturation.

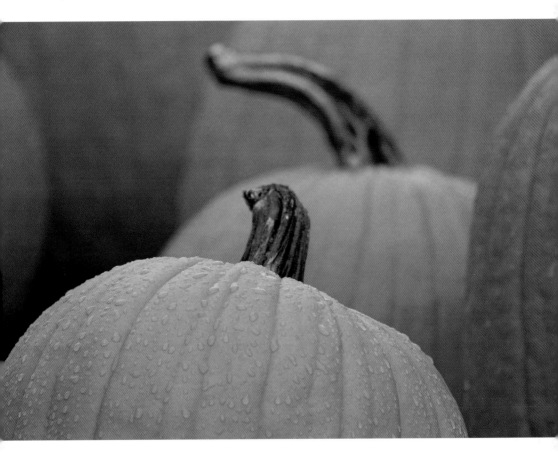

Pumpkins, Northfield, Vermont

Pumpkins always make an attractive subject. By cropping in tight and filling the frame with them, the impact of the wonderful orange colour is emphasised.

Photographer: Phil Malpas.

Technical summary: Canon EOS 10D with Canon 100–400mm f4.0L USM at 400mm, Aperture Priority, exposure 1/60 second at F5.6, ISO 100.

Yellow

Vincent Van Gogh spent the last three years of his life living under the spectacular Mediterranean skies of Provence in Southern France. In just 12 months he completed 189 paintings and it was here that he expressed his love for yellow. In a letter to his brother he stated: 'There is a sun, a light that for want of a better word I can only call yellow, pale sulphur yellow, pale golden citron. How lovely yellow is!'

Yellow is one of the subtractive primaries and one of the psychological primary hues. It can produce a warming effect and promote pleasant, happy cheerful feelings. Of course it can represent the sun and is able to call attention to itself, especially when contrasted against a dark colour. Yellow is the hue of that portion of the visible spectrum lying between orange and green, evoked in the human observer by radiant energy with wavelengths of approximately 570–590 nanometres. For maximum impact yellow needs to be of pure hue. More than the other colours it loses its power when presented as shades or tints.

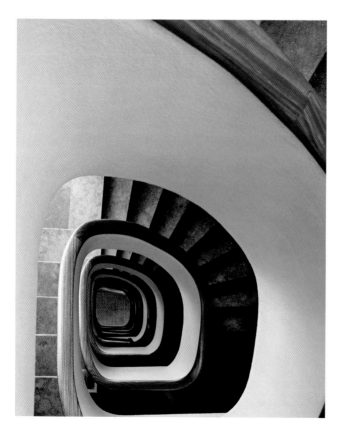

Stairs, Park Hotel, Barcelona

This spectacular Art Deco staircase offers a seemingly endless variety of compositions. The unusual yellow provides an almost organic feel to this version.

Photographer: Phil Malpas.

Technical summary: Ebony SV45TE 4x5, with Schneider Super-Angulon 90mm f8, exposure 8 minutes at F22, Fuji Velvia ISO 50 QuickLoad film.

The Manger, Uffington, Oxon (facing opposite)

In high summer, the chalk downs in Oxfordshire and Wiltshire turn an incredibly lush, deep, verdant green.

Photographer: Phil Malpas.

Technical summary: Canon EOS 10D with Canon 100–400mm f4.0L USM at 300mm, Aperture Priority, exposure 1/3 second at F45, ISO 100.

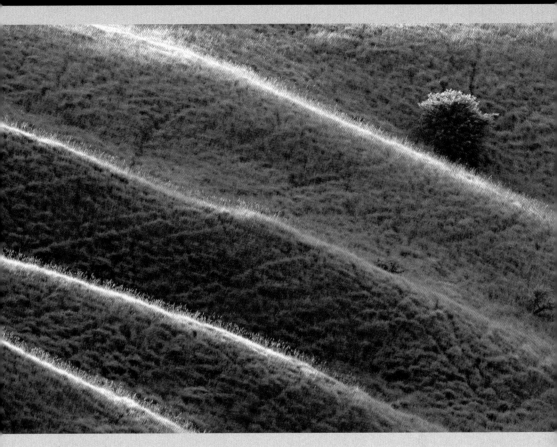

Green

Green is one of the additive or light primaries and one of the psychological primary hues. Generally, it can be seen as a 'safe' colour used to signify go, proceed and anything natural. Green is the hue of that portion of the visible spectrum lying between yellow and blue, evoked in the human observer by radiant energy with wavelengths of approximately 490–570 nanometres. It can be any of a group of colours that may vary in lightness and saturation and whose hue is that of the emerald or somewhat less yellow than that of growing grass. In photographic prints green has an ability to relax the viewer and promote a sense of harmony and well-being, but care must be taken to use other colours as punctuation in order to prevent boredom.

The British countryside can produce an overpowering 'greenness' during the summer months. The human eye can distinguish more shades of green than any other colour, yet a totally green landscape lacks the fire of autumn, the drama of winter or the hope of spring.

Blue

Blue is one of the additive or light primaries and one of the psychological primary hues. Blue is the hue of that portion of the visible spectrum lying between green and indigo, evoked in the human observer by radiant energy with wavelengths of approximately 420–490 nanometres. It can be any of a group of colours that may vary in lightness and saturation, whose hue is that of a clear daytime sky.

Blue has the ability to inspire a deep passion and at the same time provide a sense of peace and tranquillity. Blue is the colour of the sky and the sea and is associated with concepts such as stability, trust, wisdom, loyalty and truth. Tests have shown that blue can be beneficial to the mind and body by slowing the metabolism and promoting a sense of tranquillity.

'Blue colour is everlastingly appointed by the deity to be a source of delight.'
John Ruskin (English author, poet and art critic)

American car, Havana, Cuba

This car, being filmed for a movie in Havana, provides a spectacular metallic blue.

Photographer: Phil Malpas.

Technical summary: Canon EOS 5D with Canon 100–400mm f4.0L USM with 1.4x converter at 500mm, Aperture Priority, exposure 1/10 second at F22, ISO 50.

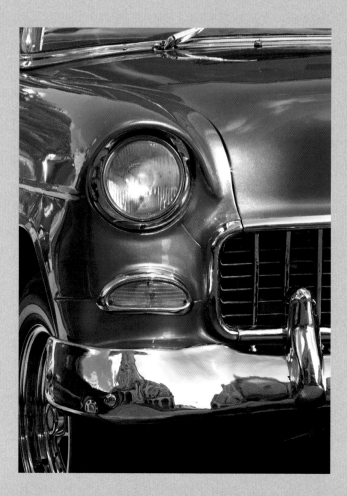

Indigo

Indigo is the hue of that portion of the visible spectrum lying between blue and violet, evoked in the human observer by radiant energy with wavelengths of approximately 420–450 nanometres. It is a dark blue to greyish purple blue.

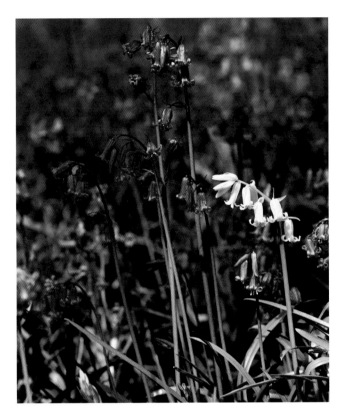

Bluebells near Chittoe, Wiltshire

Bluebells may not generally be considered as violet, indigo or even purple in colour, but they do have a tendency to reflect significant amounts of infrared light, which can make them difficult to render accurately on film. Photographed in full sun they will often appear as 'pinkbells' and even in shady conditions as seen here, there is a distinct 'reddy' tinge to the blue of the flowers.

Photographer: Phil Malpas.

Technical summary: Ebony SV45TE 4x5, with Nikkor M 300mm f9, exposure 1/4 second at F16.5, Fuji Velvia ISO 50 QuickLoad film.

As a young child you may well remember being taught mnemonics such as 'Richard Of York Gave Battle In Vain' to help you remember the colours of the rainbow (red, orange, yellow, green, blue, indigo and violet). It was Sir Isaac Newton who first proposed that light is made up of these seven fundamental colours. It is common nowadays to ignore indigo and effectively consider the wavelengths from 380–450 nanometres as a single group, usually called violet, but occasionally referred to as purple.

Violet

Violet is the hue of the short-wave end of the visible spectrum, evoked in the human observer by radiant energy with wavelengths of approximately 380–420 nanometres; any of a group of colours, reddish-blue in hue, that may vary in lightness and saturation.

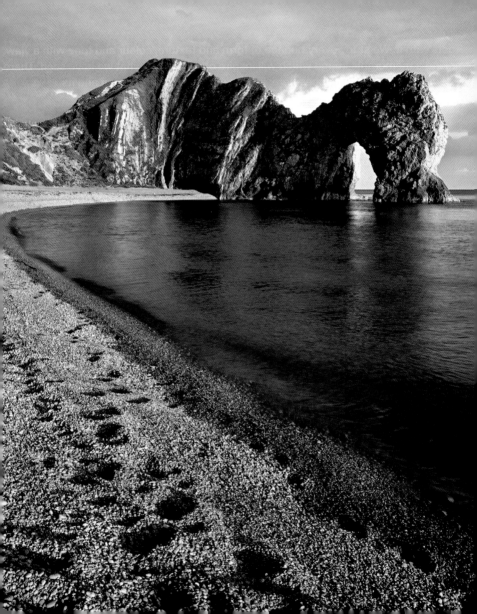

If there is one quality that will be invaluable to the photographer, it is the ability to 'see'. Every one of us who is fortunate enough to possess the gift of sight does of course look at his or her surroundings and will, at different levels, glean a certain amount of information from the process. As photographers, however, we subconsciously train ourselves to deeply analyse the tiniest detail of our subject and the way the light interacts with it. We study every nuance of form and texture, colour and tone with a view to making a memorable image which will inspire others to see what we have seen. There is no room for superficial glances here; a deep understanding of vision and its relationship to photography is required.

Although this celebration of vision is an integral part of our daily work, care is needed. Human vision differs significantly from the photographic process. The camera does not interpret light, it merely records it. Our brains, however, are subject to a whole mass of emotional, cultural and psychological influences that will give additional meaning to the things we see in front of us. It is important that we learn to recognise these influences, not only in ourselves, but also in the minds of the viewers of our work. Colours have significantly different meanings in different cultures and our photographic work will be interpreted accordingly.

The first half of this section deals with human vision, how it works and what can sometimes go wrong. It is important to grasp how our sight works so that we can compare it with the way our cameras work and be aware of the differences. The rest of the section covers the way that our vision can be affected by external influences, and how these may have a significant impact on our photographic successes. As Alfred Eisenstaedt so wisely observed: 'It is only by learning to see that we can learn to employ our cameras successfully'.

Durdle Door, Dorset

The fact that the sun sets on a different compass bearing at different times of the year is an important consideration when photographing subjects such as Durdle Door. In this image taken in September, the light is just clipping the right hand side of the arch.

Photographer: Phil Malpas.

Technical summary: Ebony SV45TE 4x5 with Schneider Apo-Symmar 150mm, exposure 1/2 second at F32, Fuji Velvia ISO 50 QuickLoad film.

The human eye

It is easy to think of vision as being the sole responsibility of the eyes, yet more correctly we should acknowledge that the eyes are simply an outpost of the brain and that we actually see with our brains. Our brains construct a complex picture of the world around us with remarkably little input from the senses. Much of our awareness is interpolated, based on knowledge, and experience and mistakes can occasionally be made.

A cross section of the human eye

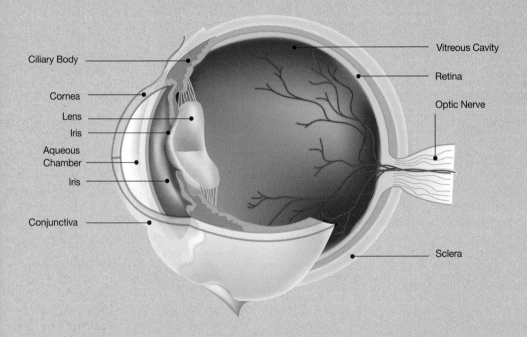

Ciliary Body

Cornea

Lens

Iris

Aqueous
Chamber

Iris

Conjunctiva

Vitreous Cavity

Retina

Optic Nerve

Sclera

The human eye is a miracle of evolution, far more capable than any mechanical camera we have been able to devise, particularly in such a compact device. When our eyes are fully adapted to current conditions (comparing night vision and bright snow conditions for example) we are able to distinguish almost 27 stops of dynamic range; that's a ratio of almost 1,000,000,000 to 1. Even under normal conditions the contrast range we can resolve is about 30,000 to 1 or 15 stops.

The main components of the eye are contained within the **sclera**, which is responsible for maintaining the eye's shape and is the anchor for the muscles that control movement. At the front of the eye are the **cornea**, **iris** and **lens**, which serve to focus the outside world on to the **retina** at the rear. The iris is an adjustable diaphragm much like the aperture ring in our cameras, which changes the size of the pupil to adjust the amount of light that can enter.

In bright conditions the pupil will be small and when it is dark it will be large. In order to focus objects at different distances on to the retina, the lens changes shape so quickly that the action is almost imperceptible to us. It is problems with the lens, particularly later in life, that often lead to farsightedness, which is caused by the lens settling into a fixed position. Luckily these problems are easily corrected by the addition of a corrective lens in the form of glasses or contact lenses in front of the eye.

The retina is a multilayered, extremely complex membrane that contains millions of light sensitive cells that detect the light entering the eye and convert it to a series of tiny electrical charges. The cells in the retina are of two main types, which are commonly known as **rods** and **cones**, and are connected through a complex series of specialised cells to the optic nerve for onward transmission to the brain.

Rods and cones have very different functions. There are about 130 million rods and between six and seven million cones in each eye. The rods are about 1,000 times more sensitive than the cones, but they only collect information in black and white. The cones are concentrated near to the optical centre of the retina and need strong light to function. It is the cones that are sensitive to colour, with each cell containing a pigment that absorbs particular wavelengths, making them sensitive to red, green or blue (actually their sensitivity peaks at about 430, 535 and 590 nanometres). The rods work better in low light and are at a greater concentration away from the optical centre. It is the rods that are responsible for our peripheral vision and, being sensitive only to black and white, they are excellent at picking up movement. This is why we often catch movement out of the corner of the eye.

The human eye

Remarkably the input from over 250 million cells, the conversion of RGB data into the full colour spectrum, the assessment of contrast, depth and spatial positioning all take place over 500 times per second, with impulses travelling through the optic nerves at over 300 miles per hour.

cones cells in the retina that only capture colour information

cornea the transparent covering at the front of the eye that protects the iris and lens

iris the human equivalent of the aperture that controls brightness and gives the eye its colour

lens the component of the eye that focuses incoming light rays on to the retina

retina the rear interior surface of the eye that holds the rod and cone cells and connects to the optic nerve

rods cells in the retina that only capture contrast (or black and white) information

sclera the membrane that contains the eye and maintains it shape whilst acting as an anchor for the various muscles that control eye movement

Colour constancy and metamerism

In the early 18th century, Sir Issac Newton was one of the first to propose that colour is not a physical property of a substance. Newton noted that the **visible spectrum of light** consists of a range of wavelengths and that colour is actually our brain's response to those different wavelengths. A red object appears as red to us not because it is red, but because its surface reflects light of the wavelengths that our brains interpret as red. An understanding of how this interpretation by the brain works, can give us a significant insight into how human vision differs from the way our film or digital camera sees the world.

One of the most remarkable properties of the human colour perception system is a phenomenon known as **colour constancy**, which ensures that our perception of the colour of an object remains constant regardless of the colour of the light source that illuminates it. We have developed this ability through millennia of evolution as a safety mechanism to help us recognise objects in different lighting conditions. Imagine you are in your kitchen, packing food for a day out. The banana that you select appears a nice ripe yellow under the tungsten lighting in your house, and it still appears to be the same colour some hours later when you are sitting outside in the bright midday sunlight. The colour of the light illuminating the fruit is significantly different between the two locations, and yet your perception of the colour of the banana does not change. This is colour constancy.

An interesting aspect of colour constancy is that it only works if the light source illuminating an object contains a range of wavelengths. The different colour sensitive cone cells in the eye register various wavelengths of light reflected by all the objects in view. Using this information the brain attempts to calculate the composition in wavelength terms of the illuminating light and then discounts this in order to perceive the actual colour of the light an object reflects. If the scene is only lit by light of a specific wavelength, as with sodium lamps for example, the brain is unable to gain enough information to make this calculation and colour constancy fails.

Colour constancy has far reaching implications for us as photographers. Whereas our visual system makes subconscious adjustments for the colour of a light source, the film or digital sensor in our camera does not. This means that we have to try to see beyond what our brain is telling us and anticipate how the camera will record the colour of the illumination. If the result is undesirable then we will need to introduce filtration or **white balance** to compensate.

colour constancy the tendency for the human visual system to make colour appear the same under different light sources

metamerism the ability of the human visual system to see things as being constantly coloured under varying coloured light sources

visible spectrum of light the small portion at the centre of the electromagnetic spectrum containing radiation with wavelengths visible to humans

white balance a term used in digital photography that relates to the camera's attempts to remove colour casts due to the colour of the light source

Erice, Sicily

When the light source is as obviously coloured as these Sicilian street lamps, it is clear that the resulting image will have a colour cast. It is far more difficult and takes practice and experience to notice more subtle shifts because our brains have the ability to compensate and convince us that the colour is normal.

Photographer: Phil Malpas.

Technical summary: Canon EOS 10D with Canon 28–135mm f3.5–5.6 IS at 105mm, Aperture Priority, exposure 20 seconds at F22, ISO 100.

Often confused with colour constancy, **metamerism** refers to the matching of colour samples under varying light sources. The important difference between the two is that colour constancy refers to a single sample and how it appears not to change under varying light sources, whereas metamerism refers to two samples and how they compare under different light sources.

Metamerism has caused significant problems for inkjet printer manufacturers in recent years, in that some prints would appear one colour under one light source and a completely different colour under a second light source. This was a particular problem when working in monochrome. You may come across references to metamerism in both printer and paper documentation as manufacturers attempt to reassure buyers that their products deal with this phenomenon effectively.

Colour blindness

Colour blindness is an unfortunate description for an inability in some humans to perceive certain colours in the same way as everybody else. A common misconception is that colour blind people see the world in black and white but actually the complete inability to distinguish any colours (**monochromacy**) is extremely rare. Humans with normal colour vision are said to be **trichromats** because their perception is based on the inputs from the three types of cone cells in the retina, which are sensitive to three different wavelength bands. There are two main classifications for colour blindness which are **anomalous trichromat** and **dichromat**. The anomalous trichromats still have vision based on three separate sensitivities, but these cover different wavelength bands to normal vision and hence they see the world with a slightly different set of colours. Dichromats have an abnormality with one type of cone cell, which means that all their colour perception is based on the input from only two wavelength bands.

Most forms of colour blindness are genetic disorders that are inherited at birth, and the most common varieties result from a gene that is carried in the X chromosome. Females have two X chromosomes meaning that both need to be defective for them to experience symptoms, whereas males have only one X chromosome and are more likely to be affected. Distributions vary across cultures, but a general average is that 8% of males and 0.5% of females may suffer to varying degrees. The defective gene is transmitted from a colour blind man to all his female offspring. In turn a female passes on a defective gene to only half her male offspring. The sons of a colour blind male will not themselves suffer because they inherit their father's Y chromosome not his faulty X chromosome.

The vast majority of cases of colour blindness result in a reduced ability to perceive differences in the yellow-green-red area of the visible spectrum. Dichromats who lack cone cells that are sensitive to long wavelengths suffer from **protanopia**, whilst those lacking cone cells that are sensitive to the medium wavelengths have **deuteranopia**. Trichromats with a mutated form of the cone cells that are sensitive to long wavelengths have protanomaly and those with mutated medium wavelength cone cells suffer from deuteranomaly. Colour blindness caused by problems perceiving short wavelength light is called **tritanopia** for those lacking sensitivity and tritanomaly for those with mutated sensitivity. Short wavelength or blue-yellow colour blindness is caused by a genetic fault in chromosome 7 and is extremely rare.

anomalous trichromat a person whose vision is based on three colours, one of which is defective

deuteranopia a form of colour blindness characterised by an insensitivity to green

dichromat a person whose vision is based only on two of the three primary colours

monochromacy a rare form of complete colour blindness in which colours can only be distinguished by their brightness

protanopia a form of colour blindness characterised by a defective perception of red, often confusing it with green or bluish green

trichromat a person with normal vision that is based on all three primary colour

tritanopia a form of colour blindness characterised by an inability to distinguish blue and yellow

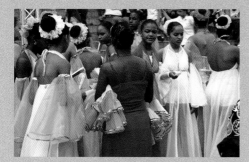

Image as seen by a viewer with normal vision

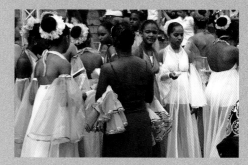

Image as seen by a protanope

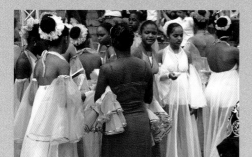

Image as seen by a deuteranope

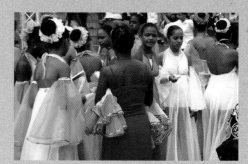

Image as seen by a tritanope

'Dancing girls, young communists' celebrations, Havana, Cuba

Colour blindness affects people differently. These images give an example of one possible scenario and are not meant to represent precise symptoms of the various disorders. The code to create these images was supplied by Vischeck – for more information on colour blindness and its symptoms, visit www.vischeck.com.

Photographer: Phil Malpas.

Technical summary: Canon EOS 5D with Canon 28–135mm f3.5–5.6 IS at 135mm, Aperture Priority, exposure 1/50 second at F14, ISO 50.

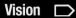

Psychological influences

When making photographs, one aim we may have is to communicate on an emotional level with the viewer of our finished work. It is a commonly accepted fact that colour influences the way we feel and consequently the colours that we place in our images can have a profound effect on the way we make the viewer feel. There are many examples in the English language where colours are used to add emphasis to the way we feel. Terms such as 'green with envy', 'feeling blue' and 'he saw red' are in common use and show us just how closely colour and feelings are linked.

In most cases any conclusions we make about colour and the way it can affect our state of mind must be considered as generalisations that will not apply in all situations. Individuals can have personal experiences with colour that can far outweigh any inbuilt genetic response. At an individual level, colours may be associated with a bad experience from the past, an association that may be totally subliminal yet very powerful. Such memories are stored by the limbic system, a collective name for various structures in the brain that are responsible for linking emotional responses and physical sensations. Within the limbic system is the hippocampus, which neurologists believe is responsible for the formation of long-term memories, of which responses to colour may well be a subset, and as such the precise reaction that our work may generate is impossible to predict.

There are, however, many generalisations that are useful to know and will of course apply to the majority of people for the majority of cases. Whereas cultural influences to colour are largely taught, psychological responses seem to be instinctive and will usually prevail in situations of extreme intensity.

Vast amounts of money has been invested in research to assess general responses to colour, particularly in the design industry where there is a clear awareness that colour choices can have a significant effect on the success or failure of a particular venture. Much of this work is based around combinations of colour and the way that colours stimulate reactions when used together, but there are also a number of accepted facts regarding individual colours as well.

'Colour is, on the evidence of language alone, very bound up with the feelings.'
Marion Milner (British psychoanalyst)

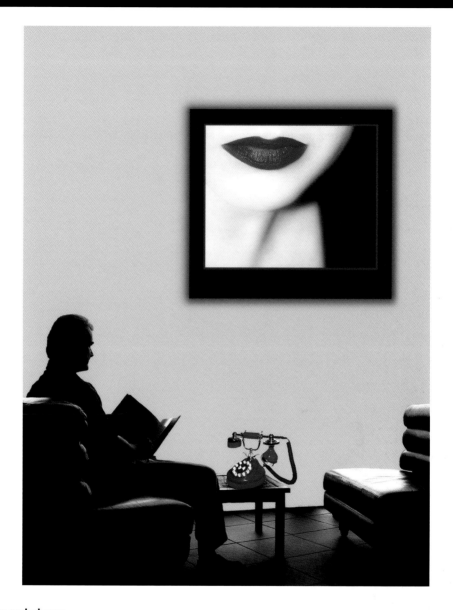

The red phone

The photographer has worked hard to only include key highlights in red (the most powerful emotional colour), which focuses the viewer's attention on the telephone and the luxurious red lips in the image on the wall.

Photographer: Ilona Wellmann.

Technical summary: This image is a montage created in PhotoImpact 8, from two original images on the Nikon Coolpix 5700. The photograph on the wall is a self-portrait of the photographer manipulated in Photoshop.

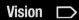

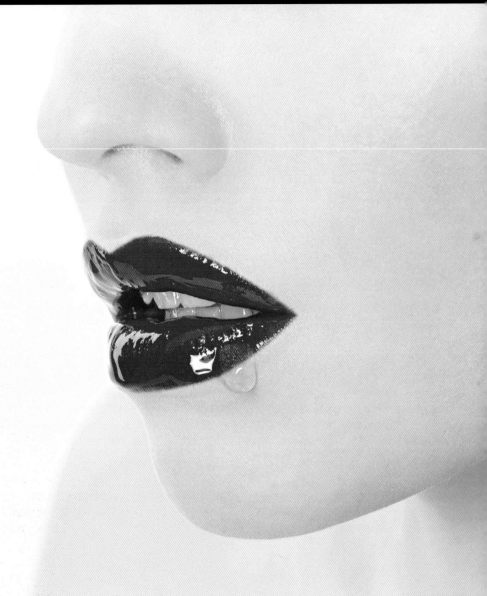

Vision

Red lips

The advertising industry has always known that sex sells and by exploiting hot, sexy colours like these deep red lips they aim to encourage a specific response in the viewer.

Photographer: Kateryna Govorushchenko.

Technical summary: None supplied.

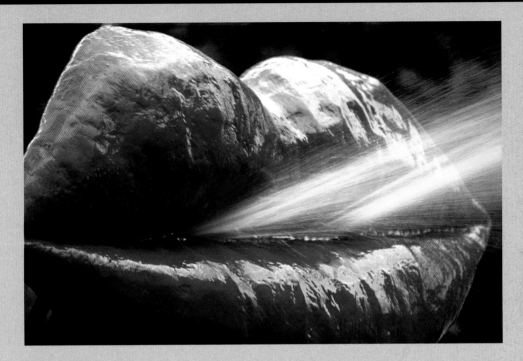

Red lips, Paris
Red is a hot, sexy colour that is associated with desire and allure, an association that was successfully exploited by the sculptor of this French water feature.

Photographer: Clive Minnitt.

Technical summary: Canon EOS 1n with Canon 75–300 f3.5–5.6 at 100mm, Aperture Priority, exposure 1/2 second at F16, Fuji Velvia 135 ISO 50.

Red: Is the most emotionally intense colour and has been shown to have a physical as well as a psychological effect on us. It can stimulate an increase in heart rate and a raising of the blood pressure and may even enhance the appetite. Red is the colour of optimism, it is sexy, stimulating and sometimes aggressive. Red will tend to stand out from the background and will grab a viewer's attention before any other colour.

Yellow: Is associated with joy, happiness, intellect and energy. It encourages cheerfulness and stimulates mental activity. Researchers have discovered that babies cry more in yellow rooms.

Green: In our modern, environmentally conscious society, is the most popular colour for interior decoration. This is probably because it has the ability to relax the viewer, partly due to its link with all things natural and general well-being. These calming properties are utilised by television companies where guests sit in green rooms to relax before making an appearance. Its position at the centre of the visible spectrum leads us to associate green with balance, harmony and reassurance. Human vision can distinguish more shades of green than any other hue. Emotionally, green has a strong connection with safety whilst also implying a sense of self-control and renewal.

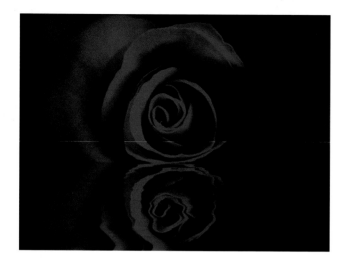

Love

Red roses in particular are associated with romance and luxury, an emotional response that the photographer has emphasised by using a Photoshop filter to provide a reflected image.

Photographer: Ilona Wellmann.

Technical summary: Nikon Coolpix 5700, exposure 1/15 second at F4.4. Reflection achieved in Photoshop using the filter 'Flood' by Flaming Pear.

Blue: In most surveys where participants are asked to name their favourite colour, blue will come top of the list. Desaturated versions of the colour are considered to be peaceful and tranquil and as a result they are often used in bedrooms to promote sleep. Blue is primarily a cold colour, however, and can visually expand a confined space leading to a cool, chilly feel. In direct opposition to the physical impact of red, the main reaction to blue is purely mental. Blue is seen to be an aid to concentration and researchers have found that weightlifters are more successful in blue gyms.

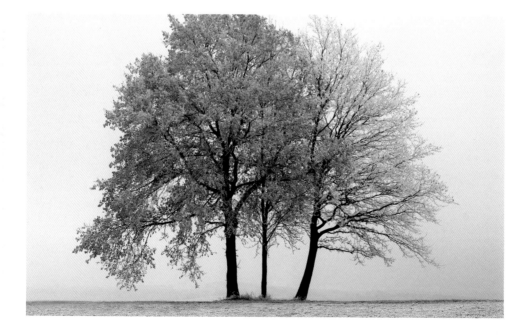

Black: In terms of reflectance, black represents no colour at all, absorbing all light that hits it and giving nothing away. It can represent authority, power, sophistication and has a stylish, timeless feel that makes it popular in fashion. Often the best use of black is when it is paired with another colour to dilute an undercurrent of oppression and menace. It works particularly well with red or white and can even enhance the impact of other colours.

White: White is associated with virginity, purity and cleanliness. As an opposite to black, white can have far more impact in small amounts, it reflects all colours and like blue can promote an impression of spaciousness. From a photographic viewpoint, white is the colour that is affected most by a difference in the colour temperature of any light source.

In terms of photography a study of colour and its hidden meanings can give clues as to why a particular image might be appreciated by one group of viewers and not another. When exhibiting prints, pay particular attention to the colour of the environment in which they will hang. If you work with models, consider the colours of clothing and backgrounds and try to enhance the effectiveness of your images by utilising colours that match your intended use. In general terms, warm colours will stand out and cool colours will recede. Experiment with your use of colour and learn from the effectiveness of your results.

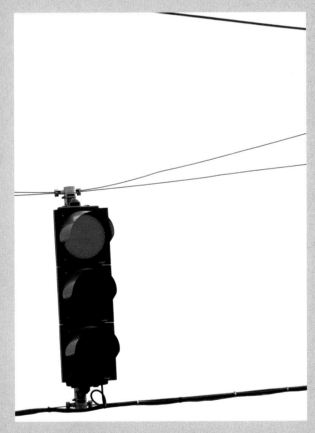

Traffic light (right)
Red is considered to represent danger. Its immediate impact means that it is used internationally as the signal to stop. This is emphasised by the stop light's inclusion in an otherwise uncluttered monochromatic composition.

Photographer: Mellik Tamas.

Technical summary: Fuji Finepix S9500 at 300mm, exposure 1/1400 second at F4.9, ISO 200, Aperture Priority.

Winter scene (facing opposite)
The trees covered in frost stand in perfect isolation with no other confusing elements in the frame. This serves to engender feelings of solitude, loneliness and purity.

Photographer: Ilona Wellmann.

Technical summary: Sony DSC F828, exposure 1/60 second at F3.5.

Cultural influences

Our inbuilt psychological responses to colour are overlaid by many cultural responses, which we learn during our formative years. Many of these responses have a basis in history or religion and can, in some cases, be very different from one culture to the next. Even within a specific culture it is possible to find differences of opinion regarding colour, especially between the old and the young, and of course any association can only be a generalisation; there will always be exceptions.

One stark difference in our cultural view of colour occurs in relation to death. In western civilisations, black has always been the colour of mourning, whilst in many eastern cultures death is symbolised by white and in Egypt the colour of mourning is yellow. Historically in the West we have associated blue with boys and pink with girls, and many products such as mobile phones are coloured this way in order to promote a response from a particular gender. In today's modern society, however, where issues of gender are becoming less distinct, these traditional colours are less applicable than they used to be. The stigma that may have been attached to a man wearing pink or purple clothes 20 years ago is no longer apparent.

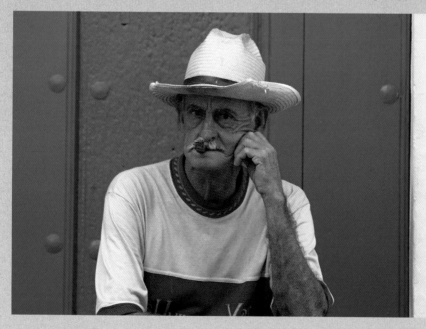

Cigar smoker, Trinidad, Cuba

The use of colour can be highly extravagant in many Caribbean cultures. Bold, bright colours tend to keep their character in strong sunlight whereas such colours can appear harsh in temperate, muted light. The city of Trinidad in Cuba is wonderfully colourful and great pride is taken in exterior decoration.

Photographer: Phil Malpas.

Technical summary: Canon EOS 10D with Canon 100–400mm f4.0L USM at 190mm, Aperture Priority, exposure 1 second at F5.5, ISO 100.

Car manufacturers have invested heavily in research to find out which exterior paint colours will sell the best. In general it can be said in the West that blue and silver cars are the most popular, whilst in the UK green cars are considered (by some) to be unlucky and are less common. Next time you are in a car park you can check this for yourself, it should come as no surprise to see a whole row of silver cars with the odd blue, red or black one interspersed.

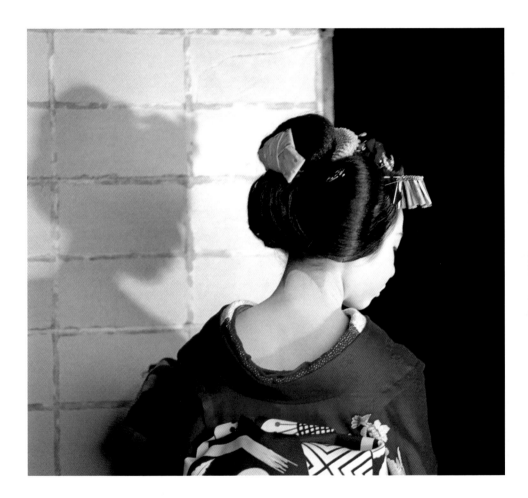

Geisha

The Chinese were actually the first to adopt white face makeup, some 300 years before the Japanese. Legend suggests that a Chinese traveller returned from the West with stories about ladies with faces 'as white as snow' and local women tried to emulate his fantastic stories.

Photographer: Frantisek Staud.

Technical summary: Nikon F100, with 80–200mm f2.8 Nikkor lens at 200mm, exposure not recorded, ISO 100, Matrix Metering.

Red: Being the colour of fire, red is used in western religions to represent God where it can also symbolise the church as a representation of the blood of the martyrs. In Catholicism, red represents Palm Sunday because of its associations with the blood of Christ, whilst in ancient Rome, the colour of blood was synonymous with Mars, the god of war. The planet Mars, which is also known as the red planet, was named in his honour. In China, red is a symbol of good luck and is often the colour of choice for brides to be. Traditionally gifts of money are given in red envelopes or packets and the colour is generally linked with celebration and prosperity. Red has strong political connotations, being mainly aligned with communism and socialism. The strong communist connection probably relates to the flag of the Soviet Union, which was predominantly red and the Red Star, a communist emblem.

Blue: In western religion, blue is the colour of the Virgin Mary and represents purity. In political terms it is often used as a counter to red and as such is aligned with conservative or democratic views. In China, blue represents immortality and in the Hindu religion it is associated with Krishna, a highly positive relationship that is reflected in cultural art. When referring to comedy as 'blue' we mean that it is perhaps vulgar or slightly risqué and pornographic films are colloquially known as 'blue movies'.

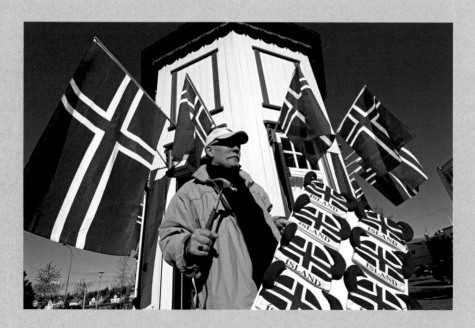

Iceland

National flags tend to provide countries with national colours. These colours become symbols of nationalistic pride and are often associated with national sports teams.

Photographer: Frantisek Staud.

Technical summary: Nikon D200, with Nikkor 12–24mm f4.0 lens at 12mm, exposure 1/750 second at F8, ISO 100, Matrix Metering.

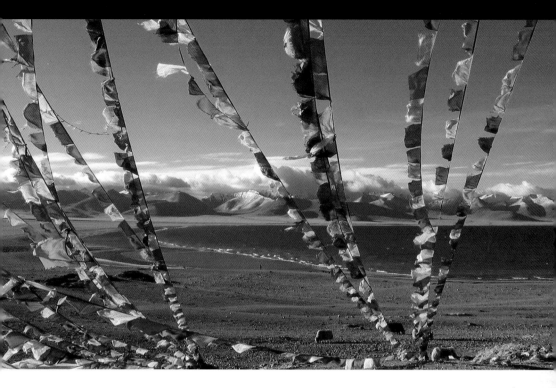

Tibetan prayer flags

It is traditional in Tibet to raise prayer flags on poles or attached to lines between buildings. These flags, which allow the wind to carry the prayers to the whole community, are usually coloured either yellow, green, red, white or blue, which represent the elements of earth, water, fire, cloud and sky.

Photographer: Not known.

Technical summary: None supplied.

Green: Green is the colour of Islam with many national flags from the Islamic world reflecting this association. The flag of Libya, for example, is completely green, and is the only national flag that consists of a single, solid colour. The national colour of Ireland is green after the national symbol the shamrock and the country itself is commonly known as the Emerald Isle. Due to its association with ecology and nature, green is adopted by political groups in over a hundred countries with policies that are deemed to be environmentally friendly. Ecological campaign groups such as Greenpeace also link themselves to this colour and any political groups that fight their cause under the banner of ecology are collectively known as 'Greens'. One interesting anomaly in the cultural significance of green is that in America it is associated with a rise in the stock market, whereas in eastern Asia it commonly reflects a fall in the value of stocks and shares.

Yellow: In many Asian cultures, yellow is viewed as an imperial or regal colour (as opposed to purple in the West) and the first emperor of China was known as the Yellow Emperor. Many countries, including the USA, have adopted this brightest of colours for their taxi cabs, a practice that was first suggested by the Chicago entrepreneur John Hertz due to the fact that yellow is the easiest colour to see at a distance. Yellow ribbons are seen as a sign of hope and were frequently raised by women in anticipation of their loved one's return from war.

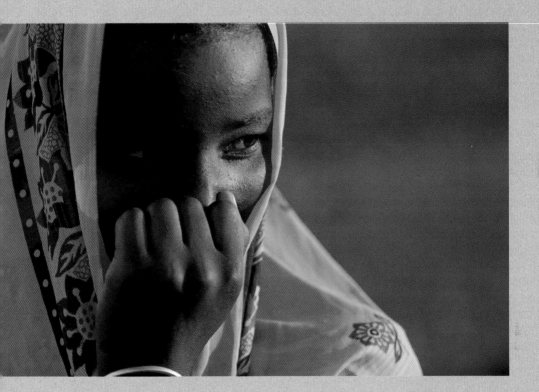

Kenya

Traditional dress can hold immense significance in different parts of the world. Often in countries with hot climates, colours are bold and exciting.

Photographer: Frantisek Staud.

Technical summary: Nikon D200, with 105mm f2.8 Micro Nikkor lens, exposure 1/400 second at F3.2, ISO 100, Matrix Metering.

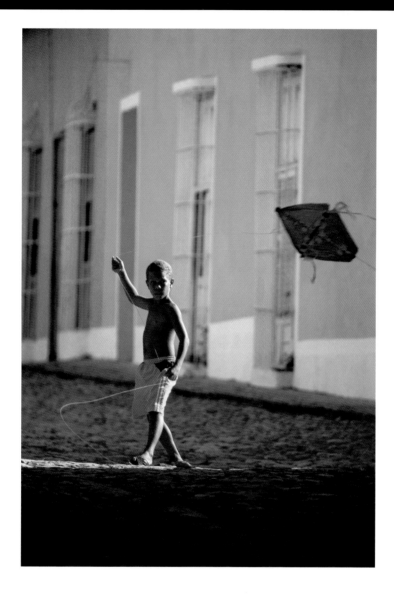

Kite flying in Trinidad, Cuba

I worked very hard to capture this image, the angle was key in order to maintain an uncluttered and limited colour palette in the background. I then had to wait for the boy to be in the narrow band of sunlight with the kite in the frame and no one walking behind. Other colour links are also apparent between the yellow shorts and the yellow building in the background and the kite and the foreground cobbles. Such links serve to strengthen the composition as a whole. I hope the result paints a warming portrait of the fun the young boy is having.

Photographer: Phil Malpas.

Technical summary: Canon EOS 5D with Canon EF 100–400 f4.5–5.6L IS USM lens at 400mm, Aperture Priority, exposure 1/200 second at F5.6, ISO 50, no filtration.

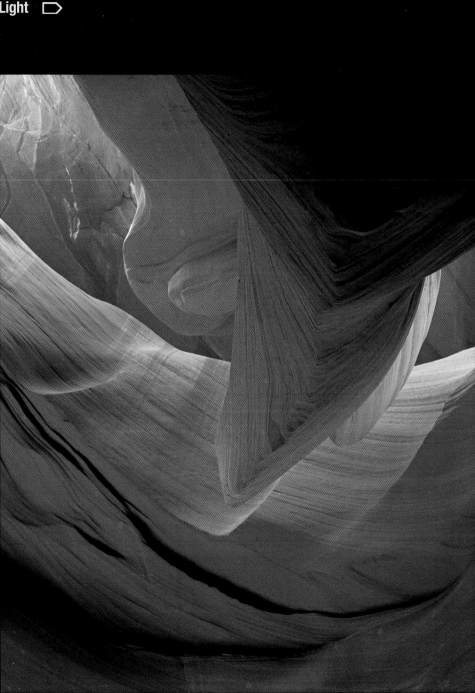

The word photography has its source in two Greek words, *phos* meaning light and *graphis* meaning stylus or paintbrush. Thus photography is often described literally as painting or drawing with light.

As photographers we soon realise that light is at the centre of everything we do. It is the fundamental component of our vocation that we cannot operate without. There are thousands of cameras on the market today with an endless variety of lenses. We have the choice of film or digital and a hundred different ways to process our images whether for print, projection or Web display. Camera manufacturers create increasingly more complex machines and develop more and more sophisticated advertising campaigns to persuade us that their product is best. Yet all this would be pointless without the one most complex, usually free, component that makes it all work – light.

Landscape photographers will frequently be out and about during the early hours of the morning or late hours of the evening. This is because they know from experience that the best light for their subject will mostly occur at the beginning and the end of each day. Of course the actual time that this happens depends on the time of year and the latitude at which they are working. Studio photographers have the benefit of absolute control over their lighting, yet they must be able to produce the perfect lighting almost subconsciously if they are to put the majority of their concentration in to the subject they are photographing. Social photographers must interact with their subject in order to make them feel relaxed and to bring out their character whilst at the same time being fully aware of how their subject is being lit. Whatever our chosen genre, our knowledge of and relationship with light must become second nature.

To be a successful photographer it is essential to study and understand light. Take your time and look around you and ask yourself questions about the way light works. Study how it reflects from different surfaces, how it creeps in to the shadows and how it appears dressed in every colour of the rainbow. Think about the words we use to describe it and think about how light changes through each day and also throughout the year. As George Eastman, founder of Eastman Kodak Ltd, said: 'Light makes photography. Embrace light. Admire it. Love it. But above all, know light. Know it for all you are worth, and you will know the key to photography'.

Lower Antelope Canyon, Page

Lower Antelope Canyon is a theatre of natural light. At the middle of the day, the sun shines down into the small slot at the top of the canyon and the light bounces around inside creating a myriad of reflections, each tinted with the rich colours of the sandstone surfaces it touches.

Photographer: Phil Malpas.

Technical summary: Ebony SV45TE 4x5 with Schneider Apo-Symmar 150mm, exposure 4 seconds at F32, Fuji Velvia ISO 50 QuickLoad film.

The electromagnetic spectrum

Visible light from red through to violet is actually only a very small part of the **electromagnetic spectrum**. The only difference between visible radiation and all the other forms of electromagnetic radiation is the amount of energy it contains. Although we only photograph in the visible spectrum (or perhaps just outside it in **near infrared**) it is worthwhile spending a few moments to try and understand the whole spectrum of radiation and where visible light fits in.

There are three units that can be used to define different types of radiation, which are **wavelength, frequency** and **energy.** A wavelength is the distance between one peak or trough on a wave and the next corresponding peak or trough and is measured in metres or fractions of metres. The frequency is the number of waves that pass a given point in a given time interval, which is measured in units called **Hertz** or **cycles per second**. Energy is a fairly complex measure relating to the energy acquired by electrons, which is measured in units called **electron volts**. Depending on the application in use, these different measures can be considered to be interchangeable.

At very low energy levels where the wavelengths of the radiation are very long are **radio waves**. Within this large band of the overall spectrum are wavelengths ranging from many hundreds of metres down to around one metre. The allocation of radio frequencies to different broadcasters is controlled at government level with specific bands being allocated to different types of radio transmission. Television, radio, mobile telephones, wireless networks and amateur radio all use radio waves.

As wavelength decreases and frequency increases, the next major band in the spectrum contains the **microwaves**. These are the same waves that are utilised in microwave ovens. At shorter wavelengths still, we move into the band of radiation known as **infrared** or **beyond red**. The infrared band is often split into three regions known as far, medium and near where **far infrared** is mostly heat and can be detected by thermal imaging cameras. Near infrared can be used to create interesting photographic images (see pages 62–69).

At the centre of the diagram opposite with wavelengths between 380 and 750 **nanometres** is the visible spectrum (a nanometre is one thousand millionth of a metre or 10^{-9} metres). Within this band is the range in which the sun and the stars emit most of their radiation, which is probably why human vision is sensitive to these wavelengths. The different wavelengths within the visible band stimulate our vision to give us the sensation of different colours. It is important to note that the radiation itself is not coloured, it simply varies in wavelength, frequency and energy. The sensation of colour is entirely created within the human visual system.

As wavelengths decrease further we move into the band of radiation known as ultraviolet or UV. UV radiation is very energetic and has the ability to physically affect the objects that it strikes. It is UV radiation that burns our skin and, in extreme circumstances, causes skin cancer. The sun emits large amounts of UV, which is normally absorbed by the ozone layer in the upper atmosphere. This is why problems with skin cancers are more prevalent in the southern hemisphere due to ozone depletion above the South Pole.

X-rays and **gamma rays** have extremely high energies, frequencies and very short wavelengths. In order to simplify the numbers, they are normally measured in electron volts (eV) with x-rays ranging from about 100 eV to 100,000 eV (100 keV) and gamma rays being all radiation with an energy level greater than 100 keV.

Most of the radiation in the electromagnetic spectrum does not reach us on the surface of the earth. The atmosphere blocks nearly all wavelengths from the shorter end of the spectrum, which is a good thing as these are the ones that are extremely harmful.

The electromagnetic spectrum

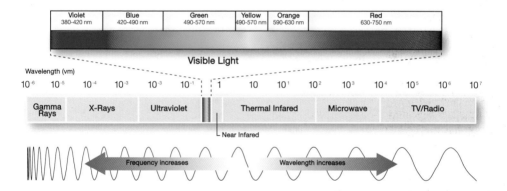

Violet 380-420 nm	Blue 420-490 nm	Green 490-570 nm	Yellow 490-570 nm	Orange 590-630 nm	Red 630-750 nm

Visible Light

Wavelength (vm)

10^{-6} 10^{-5} 10^{-4} 10^{-3} 10^{-3} 10^{-1} 1 10 10^1 10^2 10^3 10^4 10^5 10^6 10^7

| Gamma Rays | X-Rays | Ultraviolet | Thermal Infared | Microwave | TV/Radio |

Near Infared

Frequency increases → ← Wavelength increases

electromagnetic spectrum the spectrum that describes radiation of varying wavelengths from radio waves to gamma waves of which visible light is just a small part

electron volt a standard unit of energy equal to the energy acquired by an electron accelerating through a potential difference of one volt

far infrared electromagnetic radiation with wavelengths between 30,000 and 100,000 nanometres.

frequency the number of waves that pass a given point in a given time interval

gamma rays all radiation with an energy level greater than 100,000 electron volts

Hertz/cycles per second the standard measurement of frequency – the number of waves passing a given point in a given timeframe

infrared/beyond red invisible radiation with a wavelength longer than 750nm but shorter than 1mm of microwave radiation

microwaves electromagnetic radiation with wavelengths between 1mm and 10cm

nanometre one thousand millionth of a metre or 10^{-9} metres; a measure used in relation to the wavelength of light

near infrared electromagnetic radiation with wavelengths between 750 and 3,000 nanometres

radio waves the region of the electromagnetic spectrum with the longest wavelengths and lowest frequencies. Radio waves are approximately 100,000 times longer than visible light waves

wavelength the distance between one peak or trough on a wave and the next corresponding peak or trough

x-rays electromagnetic radiation with energy between 100 and 100,000 electron volts

Colour temperature

In order to give a numerical value to the colour of any light source in photography, we borrow certain terms from physics. The colour temperature of any light source is determined by comparing its hue with a theoretically perfect black-body radiator. The light source's colour temperature is the same as the thermal temperature that the black-body radiator must be heated to in order for the two to emit radiation with the same hue. The apparent colour temperature of a light source does not refer to the thermal temperature of anything other than the theoretical black-body radiator.

If this all sounds very complicated, it is probably easier to think of it this way. Any 'hot' light source will emit light, and the colour of that light will depend on the temperature of the source itself. For example, an iron bar heated to 1,000 degrees will emit light of a constant colour anywhere, anytime. In this way it is possible to give specific values to the colour of various light sources in a temperature scale that uses units called kelvins.

William Thomson was born in Belfast in 1824 where his father James worked as a Professor of Engineering. In 1832 James was appointed Chair of Mathematics at Glasgow University. Although he was a strict parent, he had a very close relationship with his son and exposed William to mathematics at an early age. William was destined for a spectacular career, which included his proposal for an absolute scale of temperature in 1848. He was knighted in 1866 and then in 1892 in recognition of his work on the Transatlantic telegraph cable he was given a life peerage (Britain's first scientific peer). He chose as his title Baron Kelvin of Largs – Kelvin being the name of the river which ran through Glasgow University, and Largs being a small town on the Scottish coast where he had set up home and where he would eventually die in 1907 at the age of 83.

The full scale of absolute temperature as we know it today was finalised some time later, but the units (kelvins) were named in recognition of Lord Kelvin's 1848 proposal. You will often see and hear colour temperatures stated in degrees kelvin or degrees K. Strictly speaking this is incorrect as according to the International System of Units (SI), colour temperature should be stated in kelvins (K), the degrees part being dropped in 1967.

Kelvins can be considered as the same as degrees Celsius (centigrade) except that the scale starts at a level called absolute zero, which is equivalent to minus 273.16 degrees Celsius (so zero degrees Celsius equals 273.16 kelvins).

The colour temperature scale

The following table gives details of the colour temperatures of various light sources.

Light Source	Colour Temperature (kelvins)
Clear blue sky	20,000
Hazy sunlight	9,000
Average shaded subject in summer	8,000
Overcast sky	7,000
Lightly overcast sky	6,300
Electronic flash	6,000
Summer sunlight	5,600
Carbon arc light	5,000
Early morning sun	4,500
Late afternoon sun	4,500
'Daylight' fluorescent lamps	4,400
Clear flash bulbs	3,800
Hour after dawn	3,500
Hour before dusk	3,500
Photoflood bulb	3,400
Tungsten halogen lamp	3,200
Tungsten floodlights	3,000
150 watt light bulb	2,900
60 watt light bulb	2,800
40 watt light bulb	2,650
Sunlight at sunset	2,000

There is one important fact to be aware of regarding the colour temperature scale. The hottest temperatures relate to the blue end of the scale, whereas the red end of the scale contains the cooler temperatures, which is the opposite of what we might expect. The reason that colour temperature is so important to us is that the colour an object appears is entirely dependent on the colour of the light source that illuminates it. A white wall will appear to be a different colour when it is lit by a red light than when it is lit by a blue light. The different light sources listed in the colour temperature table are effectively different colours and will affect the colour of our final image. We need to be aware of this in order to obtain correctly balanced results.

Bedruthan Steps, Cornwall

These pale grey rocks did not appear to be this colour to the naked eye. They were in open shade on a bright day with a clear blue sky overhead. The main source of illumination was the sky, which with a colour temperature of up to 20,000 kelvins was much bluer than the camera was expecting. The result is that the grey rocks became blue rocks in the final image, an effect that can be a superb creative tool once you learn to control it.

Photographer: Phil Malpas.

Technical summary: Nikon Coolpix 995 (compact) 8–32mm f2.6–5.1 zoom Nikkor at 12mm, Aperture Priority, 1/15 second at F6.3, ISO 100.

White balance

Almost all digital cameras on the market today support functionality known as auto white balance (AWB). With AWB activated, the digital camera tries to ascertain the colour temperature of the light source illuminating the subject and compensate for any shift in colour this might cause. To do this, the camera has to find something in the composition that it can assume to be neutral in colour (preferably something white), which is usually the brightest part of the image. It then assesses this object's colour under the given illumination, and compensates to ensure that the object appears as a neutral colour in the captured image. This compensation is then applied to the whole image on the assumption that everything in the frame is lit by the same light source as the assessed highlight. In theory if the camera is successful then any colour cast caused by the light source will be removed and the entire image will be correctly balanced.

Fondamenta Borgo, Venice

By setting the camera's white balance to tungsten, the camera was informed that the light source illuminating the subject was very red. In fact the photograph was shot in daylight and so the correction for the expected red cast has delivered an atmospheric blue toned effect to this full colour image. No post processing has been performed here, this result is entirely achieved in camera.

Photographer: Phil Malpas.

Technical summary: Nikon Coolpix 995 (compact) 8–32mm f2.6–5.1 zoom Nikkor at 18mm, Aperture Priority, 1/250 second at F5.1, ISO 100, Tungsten White Balance.

Auto white balance adjustment

Some cameras have better AWB adjustment than others, but all cameras can be fooled if conditions are not ideal, perhaps when there are no neutral colours in the composition or the light source is of an extreme colour temperature.

This is when the photographer must intervene. Compact digital cameras tend to have a number of fixed settings that can be applied with names such as 'fluorescent', 'incandescent', 'tungsten', 'cloudy', or 'sunny'. These allow you to tell the camera that the light source is of a known colour temperature and to compensate accordingly.

An alternative is to manually set a white balance by pointing the camera at a known neutral colour before composing the shot (perhaps a sheet of white paper or a white wall). You can then tell the camera that it should assume that this neutral colour should be rendered as neutral in the final image, regardless of the colour of the illuminating light source. You then recompose and shoot with this manual adjustment applied.

More sophisticated cameras allow the photographer to manually select a specific white balance setting by choosing a colour temperature in kelvins. In this way it is possible to tell the camera the colour of the light source and force it to adjust by a specific amount. This manual intervention can be a powerful creative tool once the concept of white balance is fully understood.

Derwentwater, Lake District

For this image the white balance was manually set in camera. Instead of using a neutral colour, however, the camera was pointed at a tungsten light in a nearby coffee shop to get the manual setting. By telling the camera that the tungsten light source was neutral, the camera was made to apply significant blue compensation giving this moody result.

Photographer: Phil Malpas.

Technical summary: Nikon Coolpix 995 (compact) 8–32mm f2.6–5.1 zoom Nikkor at 9mm, Aperture Priority, 1/125 second at F5.1, ISO 100, Tungsten White Balance.

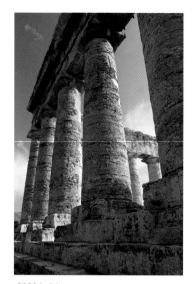

3200 kelvins

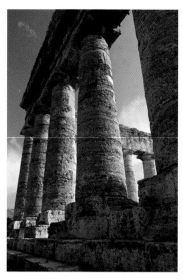

4000 kelvins

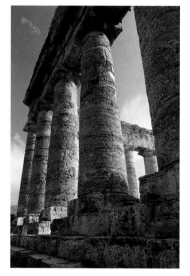

6000 kelvins

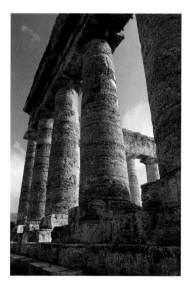

7000 kelvins

More expensive digital SLR cameras give the photographer even greater ability to control colour temperature through the manual setting of white balance. Many will allow the user to set specific values for colour temperature in kelvins usually in 100K steps. The above images were all taken with a Canon EOS 10D with the white balance set to the colour temperatures shown.

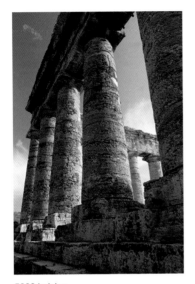

5000 kelvins

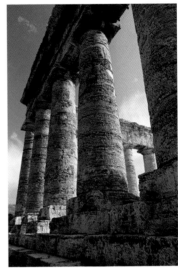

5400 kelvins (AWB activated)

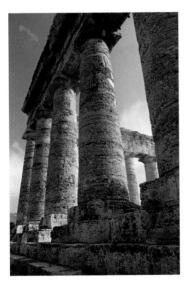

8500 kelvins

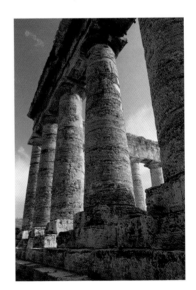

11000 kelvins

Ancient temple, Segesta, Sicily

In this image the camera's auto white balance has selected 5400 kelvins as the correct colour temperature, which is very close to daylight. In this case this selection works well, but there is an option to select colour temperature manually if one of the other images is more appealing.

Photographer: Phil Malpas.

Technical summary: Canon EOS 10D with Canon 17–40mm f4.0L USM at 20mm, Aperture Priority, exposure 1/4 second at F22, ISO 100, White Balance.

Infrared

An alternative method for producing exciting images is to use your digital camera to record images in the infrared part of the spectrum. The colours obtained can range between extremely subtle, almost monochrome to outrageously colourful depending on the camera, filters and post-processing that you apply.

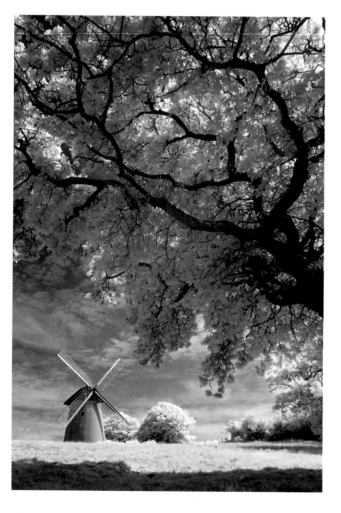

Bembridge Windmill, Isle of Wight

The camera used to capture this NIR image has had its hot mirror replaced with an internal filter that blocks all visible light and only allows infrared radiation to reach the CCD.

Photographer: Phil Malpas.

Technical summary: Converted for IR Canon EOS 30D with 17–40mm f4.0L USM at 17mm, exposure 1/25 second at F20, Custom White Balance.

As mentioned in the previous section on human vision, our eyes are sensitive to a limited band of wavelengths in the electromagnetic spectrum. Radiation is visible when it has a wavelength between 400 nanometres and 750 nanometres where a nanometre (nm) is one thousand millionth of a metre. The shorter wavelengths at around 400nm are perceived as blue light and the longer wavelengths at 750nm are seen as red light.

Wavelengths longer than the deepest reds of the visible spectrum (750nm) up to microwaves with wavelengths as long as 100,000nm can be defined as infrared. By convention, this huge range is split in to three sections: near infrared = 750nm to 3,000nm, mid infrared = 3,000nm to 30,000nm and far infrared = 30,000nm to 100,000nm. The mid and far ranges are mostly heat and are utilised by thermal imaging cameras. It is the near range (NIR) that is used for digital infrared photography.

Normally we capture all our conventional images in the visible spectrum, but typical digital camera CCDs are sensitive to light with wavelengths as long as 1,100nm, well into the NIR range. By using an appropriate filter, we can block out most or all of the visible light and allow our camera to capture just the NIR wavelengths. This opens up a whole world of image making possibilities that are completely invisible to the naked eye.

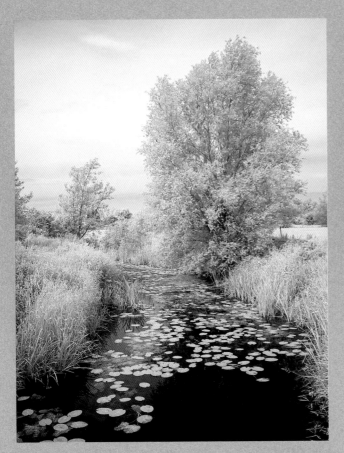

**Upper Thames
near Cricklade**

The Canon G1 camera is sensitive to infrared light. In this case a Wratten 88A filter was placed in front of the lens to block all visible wavelengths. This amazing effect, that looks like a winter sunrise, was actually captured at midday in June.

Photographer: Phil Malpas.

Technical summary: Canon PowerShot G1 (compact) 7–21mm f2.0–2.5 Canon zoom lens at 7mm, Aperture Priority, 1/13 second F2.0, ISO 100, with Wratten 88A IR filter.

Filtration for digital infrared photography

In order to ensure that your digital camera does not capture any visible light, it is necessary to use a suitable filter that only transmits light in the NIR range. Infrared filters are designed to cut out light at specific wavelengths and it is this variation in wavelengths recorded that provides differing results in the final image.

There is a confusing array of filters on the market, some of which will be readily available and some which are quite rare and correspondingly expensive. The confusion arises because of the different numbers and names given to these filters by the various manufacturers.

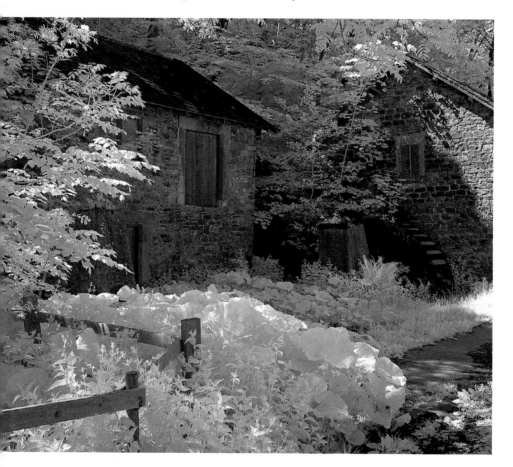

Old mill, The River Wye, The Peak District

The combination of the Canon Powershot G1 camera and Wratten 89B filter gives a very subtle coloured image, characterised by pale brown, purple and cyan tints.

Photographer: Phil Malpas.

Technical summary: Canon PowerShot G1 (compact) 7–21mm f2.0–2.5 Canon zoom lens at 10mm, Aperture Priority, 1/2 second F2.2, ISO 100, with Wratten 88B IR filter.

The Kodak Wratten series can be used as a standard way of describing the characteristics of all photographic filters. When discussing filters for infrared photography it is useful to relate the different names and numbers quoted by various manufacturers back to the Wratten Series.

Filters for infrared photography

Wratten Designation	Other Manufacturer Equivalent B+W	Heliopan	Hoya	0% transmission for wavelengths shorter than	50% transmission for wavelengths shorter than
Wratten 70		RG665		645nm	675nm
Wratten 89B	092	RG695	R72	680nm	720nm
Wratten 88				700nm	735nm
Wratten 88A		RG715		720nm	750nm
Wratten 87		RG780		740nm	795nm
Wratten 87C	093	RG830		790nm	850nm
Wratten 87B		RG850		820nm	930nm
Wratten 87A	094	RG1000	RM90	880nm	1,050nm

There are a number of sites on the Internet that give spectral sensitivity curves for many of the filters on the market. These may seem complicated, but in fact they simply show a graph of all the wavelengths of light that any particular filter allows through. Most filter manufacturers offer a range of filters that cut off at different wavelengths. In most cases, the change is gradual, so a filter does not let everything through at 750nm and nothing at 749nm. An example might be that 100 percent of light is blocked at 720nm, 50 percent at 750nm and 10 percent is blocked at 800nm. This gradual change can be plotted on a graph, and it is these spectral sensitivity curves that you find on the Internet.

Infrared filters block out nearly all visible light, meaning that you cannot see through them. Despite this, it is imperative that you never look at the sun through you infrared filter as the NIR rays can be just as harmful to your eyes as the visible spectrum. If you are using an SLR type camera, then once the filter is placed in front of the lens, you will not be able to view your composition. This is where compact cameras, like the Canon Powershot G1, have a big advantage because, with the filter in place, the infrared image appears clearly on the LCD screen.

Digital infrared – other considerations

There is one major issue that needs to be considered before venturing out with your digital camera and range of suitable infrared filters. In order to reduce contamination of the visible spectrum by light from the infrared range, most digital camera manufacturers have incorporated a small internal filter into their camera designs called a 'hot mirror'. This filter creates a big problem for digital infrared photography as it is designed to block light in the infrared range from reaching the sensor.

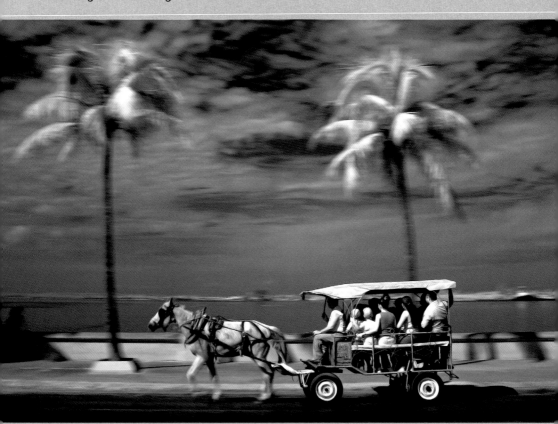

The Malecon, Cienfuegos, Cuba

This modified DSLR is extremely sensitive to NIR making hand held work possible. In this case it was necessary to stop down to F22 in order to get a long enough shutter speed to show the desired panning effect.

Photographer: Phil Malpas.

Technical summary: Converted for IR Canon EOS 30D with 17–40mm f4.0L USM at 28mm, exposure 1/20 second at F22, Custom White Balance.

The amount of infrared light blocked varies between camera models, with different cameras being sensitive to NIR light to a greater or lesser degree. Let us suppose that you place a Wratten 87 filter on the front of your lens that blocks all wavelengths shorter than 740nm. Inside your camera is a hot mirror that blocks all wavelengths longer than 720nm. The net result is that all wavelengths are blocked and you will be unable to obtain any results at all.

There does not appear to be a definitive list available that will tell you which cameras will work and which will not. It is safe to assume that most modern DSLR type cameras will have limited sensitivity to NIR light. As technology has advanced and the quality of digital results has improved, the need to avoid IR contamination appears to have increased. Camera manufacturers have made corresponding advances in the ability of the hot mirrors to block nearly all NIR light. One option is to search the second-hand market for some older models of camera. Some of the images shown here were taken with a Canon Powershot G1 3.3 megapixel camera that has excellent sensitivity to NIR. Even so, a tripod is usually required with shutter speeds generally being around 1/4 second, although in very bright conditions it is possible to hand hold with care.

Cotswold Water Park

The infrared approach works very well in conditions where there is open water and a good sky. In this photograph the open water appears very dark, adding a mysterious quality.

Photographer: Phil Malpas.

Technical summary: Canon PowerShot G1 (compact) 7–21mm f2.0–2.5 Canon zoom lens at 9mm, Aperture Priority, 1/2 second F2.5, ISO 100, with Wratten 89B IR filter.

Digital infrared photography – the results

When using a NIR sensitive digital camera with a suitable filter, the results you can expect are endlessly varied and difficult to predict. When you make your first exposure choose a bright, sunny day, preferably with some interesting cloud formations. One of the benefits of this type of photography is the wonderful way that skies are rendered. Blue skies can go completely black or a subtle shade of orange/brown, depending on the filter that is chosen. Sunlight is necessary because foliage effects are most apparent when the leaves are actually reflecting the NIR part of the light illuminating them. Again, depending on your chosen filter, foliage will appear as dazzling white or perhaps a subtle shade of cyan. Superb effects can be achieved near water as it absorbs most of the NIR light, leaving deep shades with any foliage under the surface shining through brightly. The effects of atmospheric haze are also reduced as the NIR light cuts straight through providing a crisp clear feel to the image. Photographing people can also be interesting, although the results may look more like something from a horror movie than a classic portrait!

Waterhay Church, The Cotswolds

When shooting infrared, spectacular cloud formations really stand out against the typically dark skies obtained with this approach.

Photographer: Phil Malpas.

Technical summary: Converted for IR Canon EOS 30D with 17–40mm f4.0L USM at 17mm, exposure 1/30 second at F18, Custom White Balance.

It is still possible to obtain stocks of infrared film, the majority of which give black-and-white negatives. When printed they result in deep dark skies and bright white foliage. Other properties of these films are typically very soft, often grainy images, with something of a 'halo' effect in the highlights.

All the infrared sensitive films are extremely difficult to use. They have to be loaded and unloaded in complete darkness. Many cameras are not completely shielded against infrared light and using one of these models will result in fogged film. The film itself is difficult to process; it is advisable to process it yourself, but if you do use a professional lab, make sure they are familiar with processing this type of film and that they are fully aware of the care necessary if good results are to be achieved.

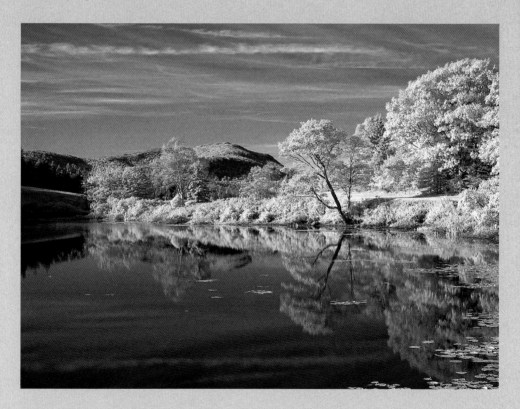

Little Long Pond, Acadia NP, Maine

The combination of the Canon Powershot G1 camera and Wratten 88A can give very exciting and unpredictable results. All the false colour shown here was obtained in camera at the time of shooting.

Photographer: Phil Malpas.

Technical summary: Canon PowerShot G1 (compact) 7–21mm f2.0–2.5 Canon zoom lens at 10mm, Aperture Priority, 1/4 second F3.2, ISO 100, with Wratten 89A IR filter.

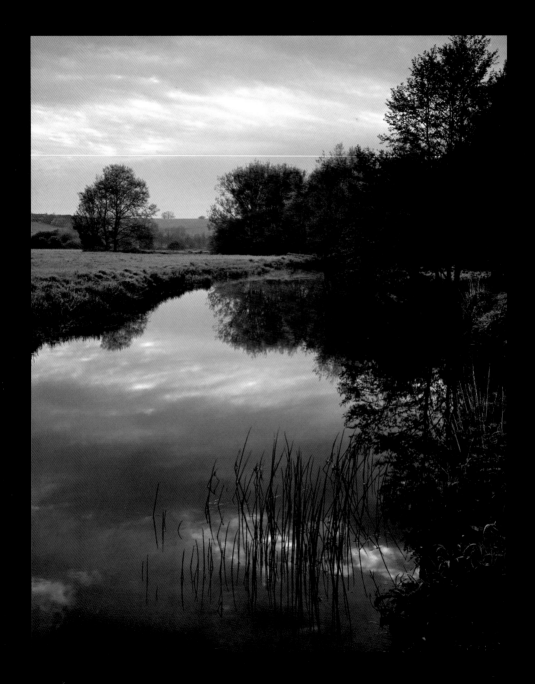

The way colour is created photographically is usually taken for granted. It is generally accepted that we point our camera at our subject, perhaps calculate a correct exposure, add some filtration and maybe wait for that perfect light. Then after pressing the shutter we either take the film to be processed or download the digital image to the computer and admire our results.

In fact there is a huge gap between these two steps – pressing the shutter and admiring the results – that we rarely think about. Paul Gauguin, the French Impressionist painter, once said: 'Colour! What a deep and mysterious language, the language of dreams', and although this part of the process may not be 'the language of dreams' that Paul Gauguin referred to, it certainly is mysterious.

This section provides the answers to questions such as: For users of colour negative or transparency film, how exactly does the image appear in the final result? How is the light captured in that tiny, thin piece of celluloid and how are all the myriad range of colours created? For digital users, how does the 'chip' turn the light entering through the lens into an image to be viewed on the computer screen and printed for display? How do decisions we make at the taking stage impact on the final printed result?

River Avon, Little Somerford, Gloucestershire

This image was captured on Fuji Velvia ISO 50 film, which has a very individual response to colour. It responds particularly well in poor light and can be relied upon to produce exciting results when conditions are suitable. Building your knowledge of how your film or digital camera responds to conditions will allow you to control colour more effectively.

Photographer: Phil Malpas.

Technical summary: Ebony 45SU 4x5, with Schneider Apo-Symmar 150mm, exposure 1 second at F32, Fuji Velvia ISO 50 QuickLoad film, with 0.3 (one stop) soft ND Grad.

Colour films

The early **monochrome films** were **orthochromatic** meaning that they were only really sensitive to the blue end of the spectrum (a fact noted in relation to Maxwell's early experiments in colour photography, see page 21). This meant that even these films were unlikely to provide a start point for capturing the whole colour spectrum. In 1873 Dr Hermann Vogel discovered a process for enhancing the sensitivity of silver halide emulsions into the green and red parts of the spectrum, a discovery that opened the way for the colour pioneers. Even so, it would be a number of years before the first truly **panchromatic** (sensitive to the whole spectrum) monochrome films were available.

Monochrome films used a single layer of emulsion that, through the exposure and development process, left black silver halides where light had sensitised the film and clear film where it had not; the black-and-white negative. Although many attempts were made using coloured screens as filters in front of panchromatic monochrome film (a development of Maxwell's three negative approach), these were complicated, expensive and lacked permanence. What was needed was to create a film with three-layered emulsions, each sensitive to a different part of the spectrum. Rather than these layers developing a metal based black-and-white negative, the layers needed to be dyed yellow, magenta and cyan so that the subtractive colour system could be used to create all the available colours.

A simplified view of colour film structure

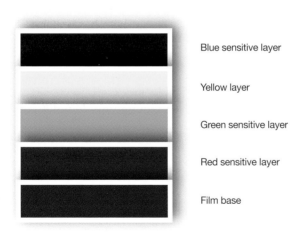

Blue sensitive layer

Yellow layer

Green sensitive layer

Red sensitive layer

Film base

In theory three light sensitive emulsions could be layered such that each layer was sensitive to blue, green or red. A yellow filter could be inserted beneath the blue sensitive layer to prevent the blue light from reaching the less sensitive green and red layers below.

dye coupling the technology used to substitute coloured dyes for activated silver halides during film development

monochrome films films more commonly known as black-and-white films

orthochromatic sensitive to all colours except red

panchromatic sensitive to all colours of the visible spectrum

In all the early attempts to create colour photographs the colour dyes were added after the colour plates had been developed. In 1912 Dr Rudolf Fischer introduced the principle of **dye coupling** where the colour dyes could be generated in the emulsion itself during development; however, there were real problems with cross-contamination of dyes. It wasn't until 1935 that Kodak was able to introduce the first modern three layer colour film, a product they called Kodachrome, that is still in use today. The Kodachrome process is unique in that there are no couplers built in to the emulsion, and so each layer has to be separately fogged and developed for cyan, magenta and yellow. This means that processing of Kodachrome film requires over 20 specific stages and must be completed using special machinery in one of a small number of Kodak laboratories around the world.

The multi-layered colour film emulsion

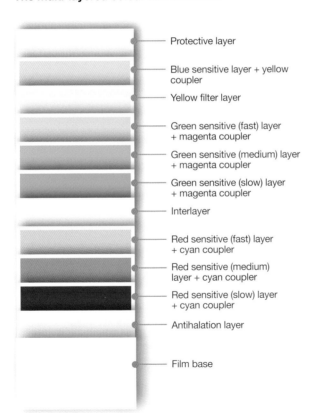

Protective layer

Blue sensitive layer + yellow coupler

Yellow filter layer

Green sensitive (fast) layer + magenta coupler

Green sensitive (medium) layer + magenta coupler

Green sensitive (slow) layer + magenta coupler

Interlayer

Red sensitive (fast) layer + cyan coupler

Red sensitive (medium) layer + cyan coupler

Red sensitive (slow) layer + cyan coupler

Antihalation layer

Film base

The modern emulsion contains multiple layers that help improve the tonal range and colour accuracy. Light enters from the top of the diagram, the second layer down being sensitised to blue light will form yellow dyes during development. The yellow filter prevents the blue light reaching the red and green layers, which are also slightly sensitive to blue. The middle layers are sensitive to green light and will produce magenta dyes during development. Similarly the red sensitive layers produce cyan dyes. The antihalation layer prevents light being reflected back from the film base and causing fogging; this layer becomes transparent during development. The whole stack of layers may be only five one thousandths of a millimetre thick.-

Eventually in 1936 scientists working at Agfa in Germany made the breakthrough that allowed the use of dye couplers in three sensitive layers without cross-contamination. Agfa introduced the product Agfacolour to the market, a product on which almost all of today's colour emulsions (except for Kodachrome) are based. By 1939 this technology had been developed to allow the production of both colour negatives and colour transparencies.

Colour transparency (positive) films

After exposure in the camera, the first stage of processing for colour transparencies is black-and-white development, which forms monochrome separation negatives in the emulsion layers. The remaining silver halides are then chemically fogged before entering a colour developer. This colour developer acts on the fogged silver halides, which form a positive image of black silver in each layer. At the same time developer by-products turn the couplers in each layer into their designated dyes. The dyes only form where fogged silver halides are present and so cyan, magenta and yellow positive images are created in their layers (this initial negative turning to positive aspect of the process is why these films are called reversal).

At this point the film is saturated with black silver halides, making it impossible to see an image. Both the negative images from the first development and the positive black image formed during colour development as a way of colour coupling the dyes need to be removed. The final stage in the process is the bleach, which removes all the silver and leaves behind the cyan, magenta and yellow dyes that form the positive image.

Fujichrome Velvia 100 Professional

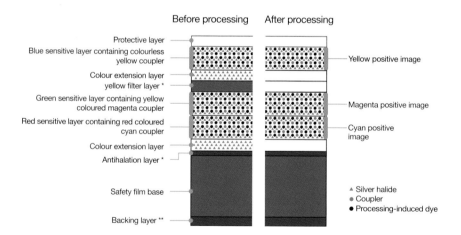

* These layers become colourless and transparent after processing.
** The backing layer becomes colourless and transparent after processing, but it is not provided with 35mm film.

This diagram shows the layer structure of Fujichrome Velvia 100 Professional (RVP100). This film incorporates the latest in coupler technology (designated as PSHC or pure stable high-performance dye-forming couplers) and colour extension layers (CEL), which Fuji claims give the film the 'ability to record the colours of sunrises, sunsets, natural greenery and other scenes with a vibrancy beyond that normally perceived by the human eye' (Fujichrome Velvia 100 Professional (RVP100); Fujifilm product information bulletin).

Colour negative films

Colour negative films use the same principal as colour transparency films in that they contain three emulsion layers, which are sensitive to blue, green and red light. These layers again have couplers that form yellow, magenta and cyan dyes. The processing stage is where things change in that there is no reversal process, and no first developer. The film is initially immersed in a colour developer, which creates the same black silver halide negative image, but the dye couplers act immediately and create negative dyed layers. As with transparency film, the black silver halides are then bleached away, leaving the dyed layers in negative form.

Fujicolor NPS160 Professional

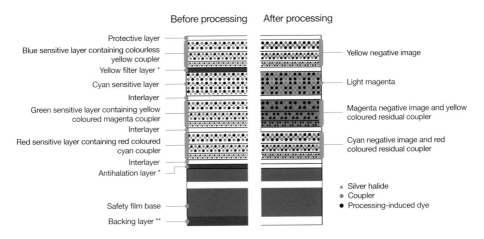

Before processing	After processing	
Protective layer		
Blue sensitive layer containing colourless yellow coupler		Yellow negative image
Yellow filter layer *		
Cyan sensitive layer		Light magenta
Interlayer		
Green sensitive layer containing yellow coloured magenta coupler		Magenta negative image and yellow coloured residual coupler
Interlayer		
Red sensitive layer containing red coloured cyan coupler		Cyan negative image and red coloured residual coupler
Interlayer		
Antihalation layer *		▲ Silver halide
		● Coupler
Safety film base		● Processing-induced dye
Backing layer **		

* These layers become colourless and transparent after processing.
** The backing layer becomes colourless and transparent after processing, but it is not provided with 35mm film.

This diagram shows the layer structure of Fujicolor NPS160 Professional colour negative film, which incorporates an additional light magenta layer.

The characteristic pink/red mask that occurs in colour negatives is caused by the yellow and pink mask that remains in the green and red sensitive layers in places where magenta and cyan dyes are not formed. Paper used to make prints from colour negatives is manufactured to allow for this colour mask. In fact, all colour negative films are designed to perform at their best with the same manufacturer's printing products. The printing paper itself works on exactly the same principle as the film, turning the negative image into a positive. The two development processes covered here are now standardised across the industry for the majority of films. Colour transparency films are developed using the E6 process and colour negative films are processed using the C41 process.

Daylight and tungsten balance

Regular users of film will be familiar with the words **daylight balanced**. In order to represent colour consistently, film manufacturers have agreed upon a standard for the expected colour of light (**photographic daylight**). This equates to a colour temperature of approximately 5,500 kelvins, which means that the film expects the colour of the light source illuminating the subject to be 5,500 kelvins. If the colour temperature is any higher, the image will have a blue cast, and if it is any lower the cast will be red. Subtle differences will be hardly noticeable, but with clear blue sky being 20,000 kelvins and sunlight at sunset being 2,000 kelvins obviously the light source will not always match the film.

There are a number of solutions to this problem. The first is to do nothing at all and accept the colour cast, because the colour of the light is often the very reason we choose to make a photograph. The second is to employ filters to correct the difference and bring the colour of the light source into line with what the film is expecting. This approach is covered in detail in the filtration section of this book. The third solution is to use an artificial light source like electronic flash. Flash is designed to produce light of the same colour temperature as daylight film expects.

The final option, if you are shooting indoors under standard lighting, is to buy a different sort of film which is **tungsten balanced**. This film expects the light source to have a colour temperature of 3,200 kelvins, which is matched to standard household light bulbs. Of course, there are many other types and colours of artificial light and film users will in most cases need to filter for these.

Queenswood Arboretum, Herefordshire

Working in woodland is notoriously difficult, particularly when it comes to balancing the colour temperature of the light source to that expected by the film. When creating this image, David needed to be aware that the subject was being lit by indirect light from the sky above and that, if left unfiltered, the spectacular warm reds and yellows would have been weakened by an overpowering blue cast. His knowledge of light, and the characteristics of Fuji Velvia, allowed him to take the bold decision to use an 85C warming filter. This is a very strong filter, which will reduce the colour temperature of a light source of 10,000 kelvins to the daylight balanced 5,500 kelvins. If you hold one to your eye, it has a disturbingly pink-orange colour that appears to dominate all the colours in the scene. This film also requires adjustment for reciprocity failure, such that any exposures of 16 seconds require two thirds of a stop additional exposure and a 10 magenta filter. This is necessary as the film has a bias towards green for long exposures, which David calculated would be addressed with the 85C filter.

Photographer: David Ward.

Technical summary: Linhof Technikarden 150mm, exposure 15 seconds at F22, Fuji Velvia ISO 50, with Wratten 85C.

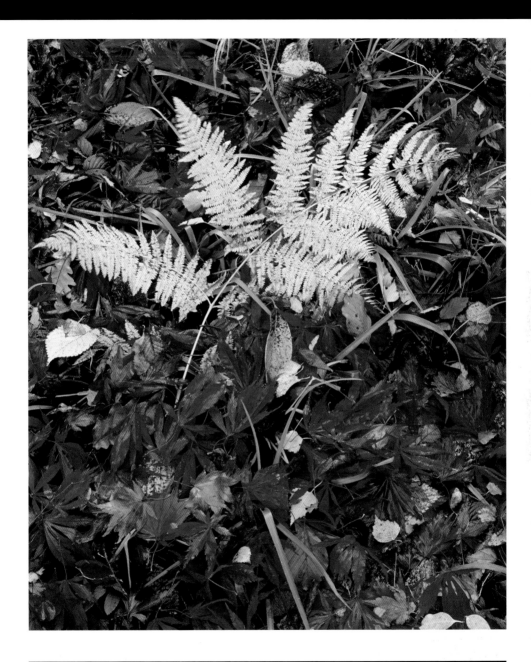

daylight balanced the term applied to films that are designed for use in normal daylight conditions
photographic daylight a mixture of direct sun and open blue sky illumination, as found in Washington, DC, USA on a typical clear day between the hours of 10am and 4pm
tungsten balanced the term applied to films that are designed to produce the effect of daylight illumination under tungsten lighting

Digital colour

Digital cameras are in fact very similar to film cameras. They consist of a light tight box with a lens to focus the subject on to a specific plane and they have a shutter and aperture ring for controlling exposure. In fact, if a modern film-based SLR was placed next to a digital SLR it would be difficult to notice an external difference (apart from the giveaway 'D' on the maker's badge). Internally there are two major differences between the two. The digital camera has a chip or sensor in place of film and some form of storage for storing captured images.

There are two surprising facts about digital camera sensors. Firstly, they only see the world in black and white. Each photo receptor on the chip (known as a **photosite**) simply records the quantity of light it receives during an exposure, it does not know what colour that light is. Secondly, it is usual to imagine that the sensor is completely covered with photosites, but in fact they actually take up less than half of the surface area.

A digital sensor close up

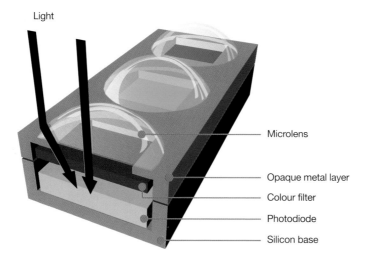

Light

Microlens

Opaque metal layer

Colour filter

Photodiode

Silicon base

This diagram shows three photosites on a typical digital camera sensor. The photosites are spread across the sensor with gaps between them – they do not cover the entire surface. The micro lenses serve to focus the incoming light into the photosites.

There are a number of approaches to collecting colour information when the sensor only records quantitative information. In studio photography it is common to use a digital back that consists of a single row of photosites. The row of photosites scans across the image area collecting information for each of red, green and blue. These backs (called scanning backs for obvious reasons) can produce high quality images, but they are very slow to use and cannot deal with moving subjects. Another alternative is to use three sensors in a single camera and a device called a 'beam splitter' to direct information about red, green and blue to only one of the three sensors. High quality images are also possible from this approach, but the cameras themselves are bulky and expensive.

There is a much simpler approach, one that is used in all compact and digital SLR cameras. In order to address the fact that the photosites only collect the quantity of light from each exposure, the sensor is completely covered with a mosaic of tiny coloured filters, one for each photo receptor. This colour filter mosaic is called a **colour filter array (CFA)** and its job is to limit the light that is allowed through, such that a photosite with a red filter above it will record only the red portion of light and one with a green filter will record just green. Designers have utilised a number of different patterns of filters in different sensors, but the most commonly used today is the **Bayer pattern** (named after Dr Bryce Bayer, the engineer at Kodak who invented it).

A Bayer pattern

This is the most commonly used colour filter array on a digital sensor. Other patterns include one with cyan, magenta, yellow and green filters.

Bayer Pattern the most common pattern of filters that covers the sensor in a digital camera
colour filter array (CFA) the mosaic of colour filters that covers the sensor in a digital camera
photosite an alternative name for a single photo receptor on a digital camera sensor, commonly known as a pixel

The Bayer pattern

The Bayer pattern has two noticeable features. Firstly there are twice as many green filters as there are red or blue filters. Consequently the sensor will pick up 50% of the green light that hits it, and 25% of the red and blue light that hits it. The reason for this emphasis on green is that the human eye is more sensitive to green light than red or blue and the extra information is required to make true colour images. Under this filter arrangement two thirds of the light that hits the sensor is blocked meaning that these one-shot colour sensors are a lot slower (requiring higher light levels) than a panchromatic monochrome sensor would be. For this reason the low-light applications of this technology, such as security cameras, work almost exclusively in monochrome.

The second feature is that any single photosite on the sensor is surrounded by photosites that are filtered by the other two primary colours. This is the key to capturing full colour information at each photosite, using a technique called **demosaicing**.

Once the image has been captured, one of the first steps is to make an assessment of white balance. It is assumed that the brightest parts of an image are likely to be neutral in colour and the values of all the photosites are adjusted in accordance with the colour of these particular regions of the image.

At this point the demosaicing (sometimes called **interpolation**) process begins, the objective of which is to allocate red, green and blue values to each photosite (even though each one has only captured data relevant to one colour). This process is complex mathematically and the research and development departments of camera manufacturers have invested significantly in testing a myriad of different approaches. A simplified view of the calculation is still beneficial in understanding the way that the full colour image is constructed.

How a full colour image is constructed

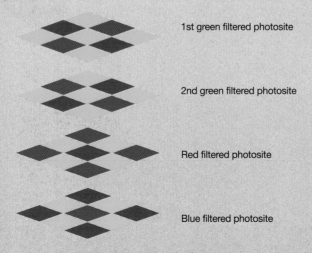

1st green filtered photosite

2nd green filtered photosite

Red filtered photosite

Blue filtered photosite

The four diagrams opposite show the options for individual photosites and their corresponding filters. In the two cases where a green filter is at the centre, it is possible to allocate it a blue and red value by looking at the photosites to the left and right and above and below. When blue or red are at the centre it is possible to use the values of the photosites on the diagonals for either red or blue respectively, and on the same rows and columns for green. In fact the algorithms used are more complex than this and the values of photosites even further away are taken into account when calculating RGB values.

This complex approach to gaining RGB values for each photosite has a number of inherent problems associated with it that designers have had to address. Firstly, if you imagine a very small or fine detailed red object in your image, that crosses a green photosite, no information about this object would be captured at all. To counteract this the colour filter array is covered by another set of filters that include the hot mirror for blocking infrared and an **anti-aliasing filter** that helps with this problem. The anti-aliasing filter removes the highest frequency detail, but has the side effect of making the details in the image appear softer than they would without it (one of the reasons why most digital images require sharpening, although in some cases this is also completed as part of the demosaicing process).

Another problem encountered is artefacts in the image known as **noise,** which can be considered as interference within the sensor itself (something like the background hiss of a radio signal). Noise is more prevalent as temperature rises, and exposure times increase. There are ways to reduce it and modern cameras adopt techniques such as sampling a group of photosites without exposure and removing the calculated noise overhead from the captured image. Top of the range DSLR cameras have significant amounts of computing power available and noise is much less of an issue.

The description given here of the process for capturing colour images digitally is heavily simplified, and yet even this appears to be extremely complex. Add in a few other tasks that you may ask your camera to complete like JPEG compression and it is a wonder that the final image resembles the original subject at all! One approach if your camera supports the option is to shoot **RAW** files. RAW files include just the RAW data captured at the photosites. No demosaicing is performed in camera. This allows you to utilise far more processing power and potentially better demosaicing algorithms on your PC at a later date.

anti-aliasing filter used in digital cameras to blur fine detail so that colours can be captured accurately

demosaicing the process that estimates the red, green or blue values that a digital camera does not capture through its colour filter array

interpolation the act of adding data to the captured image in digital photography to either create a full colour image or increase the image size

noise statistical variations in the response to light by a digital camera sensor that result in a degradation of the captured image

RAW files digital files that consist of the unprocessed data captured by a digital camera

An ability to successfully and confidently utilise filters is an essential skill for those wishing to excel in colour photography. Ironically when filters are used properly a key aim is to produce an image where it is impossible to tell that one has been used. The main reason for selecting a filter in a particular situation is to enable the film or digital camera to capture the subject as the photographer sees it. Filters are used to overcome specific limitations in the photographic process and aid the communication of the photographer's vision to the viewer of the final result.

The filters discussed in this section are of two main types. There are those that actually change the colour of the final image and those that are used to reduce the subject contrast range in order to capture full colour throughout the composition.

Of these, the neutral density graduated filters, which are used to reduce contrast range are useful for both film and digital users. The remaining filters are not required by those using digital cameras. Digital users can utilise white balance to deal with any colour correction they need to achieve. In fact the auto white balance functionality of most modern digital cameras would partially negate the impact of colour correction filters anyway.

There is one special filter that falls outside the two main categories and that is the polarising filter. An essential tool for digital and film users alike, the polariser can enhance an image in ways that cannot be achieved in any other way.

There are numerous filters and filter systems on the market today, produced by manufacturers from all over the world. It is important to purchase the highest quality filters you can afford, any compromise here will directly affect the quality of your results. In general the most expensive filters are the best quality and will be more likely to achieve the objective of being unnoticeable in the final image.

The most important thing to remember is that even using the most expensive filters will not drag a fantastic result from a poor subject. Filters will help you to realise your vision, they will not create it for you!

Abandoned House, Scotland

The colour contrast in this image is caused by the sunlight shining through the curtains on the left, light that was far warmer than the film was expecting. This adds to the atmosphere and the use of filtration to try to correct it would have been a mistake.

Photographer: Phil Malpas.

Technical summary: Ebony SV45TE 4x5 field camera with Schneider Super-Angulon 90mm f8 lens, exposure 15 seconds at F32, Fuji Velvia 50 rated at ISO 50, no filtration.

Filter systems

There are two major approaches to filtration available, each of which has a number of advantages and disadvantages associated with it. A lot depends on your individual requirements as to the best approach to take, particularly the number of lenses and the type of camera you use.

Circular, screw-on filters

Many filters are available in circular form and have a filter thread equivalent to a particular diameter in millimetres. Each lens that you own will have its filter thread diameter marked in millimetres near the front element. If you own a number of lenses with different filter thread sizes, you will need to purchase multiple copies of each filter you wish to use. If you are using a compact digital camera you will probably only need one filter of each type as you only have one lens to cover.

Circular filters are often made of high quality glass and can be quite expensive individually, especially in large thread sizes. One option is to accept that you need to buy the larger, more expensive filters and then also to purchase **step-up rings** that convert smaller lenses to use larger filters. The problem with this approach is that the step-up ring moves the filter further from the front of the lens and can lead to **vignetting** and a greater likelihood of flare from unwanted, reflected, stray light.

Once you have a set of circular filters they will last a lifetime, provided that you keep them clean, do not drop them and avoid any scratches. They are best suited to frequent or constant use, so filters such as ultraviolet, warm-up, soft-focus, overall ND, polarisers and coloured filters for monochrome photography work best in this type.

Although they are available, circular filters are not suited to any type of **graduated filter** because there is no option to position the area of graduation relative to the lens. Generally, circular grads will have the graduated area near the centre, which will not always suit your chosen composition.

The Lee filter system

The alternative to circular filters is the approach commonly known as **system filters**, where you purchase an entire system from the same manufacturer to cover all your filtration needs. All filter systems consist of three main components, the first of which is a circular ring that is threaded to fit a specific filter ring size. The outside of these rings are all equal in size and allow the fitting of a filter holder that can be adapted to accept either a single filter, or a number of filters combined. Last are the filters themselves, which are either square, in the case of non-graduated filters, or rectangular as for all the graduated filters. The rectangular shape allows the accurate positioning of the graduated section of the filter anywhere in the frame. The filter holder can also be rotated on the adapter ring allowing the use of graduated filters at any angle.

The Lee system features an additional 105mm ring on the front of the filter holder, which accepts the 105mm polariser offered by Lee or Heliopan. The advantage here is that one relatively expensive polariser will cover all of your lenses. Lee also sell specially made lens caps that will fit on to the adapter ring so that you do not have to remove it to put the lens away. Most manufacturers' lens caps will not fit once the adapter ring is in place.

The most common ranges of system filters are offered by Cokin, Lee and Hi-Tech although other manufacturers such as Singh-Ray and Sinar offer high quality, expensive filters to fit the other manufacturers' filter systems.

System filters have the advantage that you will generally only need to purchase one filter of each type. Multiple filters are easy to use together and the large size of the filters tends to avoid vignetting with all but the widest lenses. Rectangular filters like these are also the only viable way to use graduated filters, which may be reason enough to adopt this approach.

circular filter a filter that has a particular thread size, which is designed to fit a certain size of lens

graduated filter a filter that is partly clear and partly coloured (or ND) that is used to apply either a false colour or neutral density to part of an image

step-up rings adapters that allow the fitting of an oversized filter to the front of a smaller lens

system filters photographic filters where a range of filters will fit into a single filter holder which can then be used to cover a variety of lenses

vignetting a problem that occurs with wide-angled lenses when the filter is visible in the final image

The Kodak Wratten series

Frederick Charles Luther Wratten (1840–1926) was an English inventor who established one of the first photographic supply businesses in 1878 in London. Wratten and Wainwright manufactured and sold various photographic plates and in 1906 Wratten, in partnership with Dr Kenneth Mees, marketed the first panchromatic plates in England. Wratten is most famous for the manufacture of photographic filters to exacting tolerances, and it was this talent for invention that attracted the mighty Eastman Kodak company to buy Wratten and Wainwright in 1912. As part of the buyout deal Dr Mees went to work for Kodak, on condition that the series of filters would continue to bear the Wratten name.

The Wratten designations are still used today as an industry benchmark. It is true that many filter manufacturers give their filters their own names, yet they will almost always provide the Wratten equivalent of any filters they sell.

Common Wratten filter designations

Common Wratten filter designations	
Wratten no.	**Colour**
2B, 2E, 3, 8	Pale to mid-yellow
9, 11, 12, 15	Deep yellow
16, 21, 22	Yellow-orange to deep orange
25, 26, 29, 92	Red to deep red
32	Magenta
34A	Violet
38A, 44, 44A, 47, 47A, 47B, 98	Blue series: Light blue-green through blue to deep blue
58, 61, 99	Green to deep green
18A	Blocks all light other than UV for ultraviolet-reflection photography
39	Blue
87, 87C, 88A , 89B	Filters for infrared photography
90	Monochrome viewing filter
102, 106	Filters used in densitometry

When using Wratten filters in colour photography, it is necessary to take into account the fact that all filters block certain wavelengths and, as such, reduce the amount of light reaching the film. Each filter has an associated **filter factor**, which tells us how much extra exposure we need to give in order to compensate for the filter's effect. If you are using an automatic **TTL (through-the-lens) metering system** then you can allow the camera to automatically compensate for any filters you use. If you are using a hand held or manual metering system then you will need to adjust your exposure accordingly.

Wratten filters for colour photography

Common Wratten filter designations		
Wratten no.	Colour	Filter factor
85B	Yellowest	2/3 Stop
85		2/3 Stop
85C		2/3 Stop
81EF		2/3 Stop
81D		2/3 Stop
81C		1/3 Stop
81B		1/3 Stop
81A		1/3 Stop
81	Least yellow	1/3 Stop
82	Least blue	1/3 Stop
82A		1/3 Stop
82B		2/3 Stop
82C		2/3 Stop
80D		2/3 Stop
80C		1 Stop
80B		5/3 Stops
80A	Bluest	2 Stops

The 85B and 80A filters are specifically designed to correct for the use of tungsten film in daylight conditions, or the opposite – daylight film under tungsten lighting.

For outdoor photography the most useful filters will be those in the 81 series – known as warm up filters.

filter factor the amount of additional exposure required to compensate for the use of a particular filter
TTL (through-the-lens) metering system the ability of some cameras to take meter readings through the lens

Mired and mired shift

When utilising filters to correct colour there is one important fact we must consider. If we were only concerned with measuring the colour temperature of a specific light source then the Kelvin scale would be sufficient for most of our requirements. When selecting a filter to match a particular light source to the colour balance of our film, we are actually dealing with a change to the colour of the light source.

Any single filter will affect the colour of the light source differently depending on what colour it is in the first place. If we were to view a yellow light source through a filter of the same colour we would detect virtually no change. If instead we looked at a blue light source with the same yellow filter, the effect would be significant. In practice, for example, a Wratten 81B filter reduces the colour temperature of daylight by 715 kelvins, but lowers the colour temperature of tungsten light by only 65 kelvins. This makes things extremely complicated; if every filter will have a different effect each time we use it, how are we supposed to predict what the result will be?

The solution is to divide the kelvin rating of a light source into one million to give its mired value. Similarly, by dividing the mired value into a million we can convert back to kelvins.

The acronym mired (pronounced my-red) is short for micro reciprocal degrees, the key being the word reciprocal. By dividing the kelvin value into a million we arrive at the mired scale, which runs in the opposite direction to the Kelvin scale. Blue light sources have a low mired value and a high kelvin value and red light sources have a high mired value and a low kelvin value.

Just as light sources can have mired values associated with them, so can filters. The mired values associated with filters are known as mired shifts. This is because the filters at the yellow end of the scale have positive values and shift the colour of light higher up the mired scale. Conversely, filters at the blue end of the scale have negative mired values and shift the colour of light to a lower mired value.

The advantage of the mired system is that any given filter will always shift the colour of light by the same mired value, regardless of the colour of the light source. When using multiple filters, it is possible to add their mired values together to calculate the overall shift they will cause. We can therefore say:

mired value of light source + mired value of filter(s) = mired value of result

Mired shift values for common colour correction filters in the Wratten scale

	Wratten Filter	Mired Shift	Filter Factor (stops)
Yellowest	85B	131	2/3
	85	112	2/3
	85C	81	2/3
	81EF	52	2/3
	81D	42	2/3
	81C	35	1/3
	81B	27	1/3
	81A	18	1/3
Least Yellow	81	9	1/3
Least Blue	82	-10	1/3
	82A	-21	1/3
	82B	-32	2/3
	82C	-45	2/3
	80D	-56	2/3
	80C	-81	1
	80B	-112	5/3
Bluest	80A	-131	2

This table gives the mired shift values associated with the common colour correction filters in the Wratten scale. The filter factor is the amount of exposure adjustment that needs to be made to compensate for the reduction in light caused by the filter.

Filters to be used when correcting light sources

Light Source	Colour temperature in kelvins	Mireds	Wratten filtration with daylight film	Wratten filtration with tungsten film
Clear blue sky	20000	50	85B	
	14286	70	85	
	10000	100	85C	
Hazy sunlight	9000	111	81A + 81EF	
Average shaded subject in summer	8000	125	81EF	
	7143	140	81D	
Overcast sky	7000	143		
	6803	147	81C	
Lightly overcast sky	6452	155	81B	
Electronic flash	6098	164	81A	
	5780	173	81	
Summer sunlight	5600	179		
DAYLIGHT BALANCED FILM	5500	182	NO FILTER	85B
	5208	192	82	85 + 81
Carbon arc light	4950	203	82A	85
	4673	214	82B	
Early morning/late afternoon sun	4500	222		
'Daylight' fluorescent lamps	4400	227	82C	85C
	4200	238	80D	
Clear flash bulbs	3800	263	80C	81EF
	3676	272	82C + 82C	81D
	3571	280	80C + 82A	81C
Hour after dawn/before dusk	3500	286		81B
	3448	290		
Photoflood bulb	3400	294	80B	81A
	3333	300	80B + 82	81
Tungsten/halogen lamp	3200	313	80A	NO FILTER
TUNGSTEN BALANCED FILM	3200	313	80A	NO FILTER
	3125	320	80A + 82	82
	3030	330	80A + 82A	
Tungsten floodlights	3000	333		82A
	2941	340		
150 watt light bulb	2900	345		82B
	2857	350	80A + 82B	
60 watt light bulb	2800	357	80A + 82C	82C
	2703	370		80D
40 watt light bulb	2650	377		
	2632	380		
	2538	394		80C
	2353	425		80B
	2252	444		80A
Sunlight at sunset	2000	500		80A + 80D

Using this table it is possible to work out which filter you need to use to correct for a light source of a different colour temperature to the film you are using.

For example, imagine that you have decided upon your composition and the main light source is a lightly overcast sky. The light source has a colour temperature of 6452 kelvins, which when divided into one million equates to 155 mireds. The film you are using is daylight balanced and is expecting a light source with a colour temperature of 5,500 kelvins, which is equal to 182 mireds. The difference between the film and the light source in mireds is 27 and from the table on page 89 it can be seen that a Wratten 81B is the correct filter to use (155 + 27 = 182).

Further analysis of the mired scale shows that the difference in mireds between daylight balanced film (182 mireds) and tungsten balanced film (313 mireds) is 131 mireds. From the Wratten scale the 85B yellow filter adjusts colour by plus 131 mireds and the 80A blue filter adjusts colour by minus 131mireds. These filters are designed to correct for the use of tungsten film in daylight conditions, or the opposite, daylight film under tungsten lighting.

Of course, if you are looking to use your filters creatively then you may well decide to use them to increase the difference between the light source and the film. The table will still be of use, but you must remember that if you are seeking to warm up an already warm light source then the filter will have a smaller effect than it will on a cool light source.

Colour temperature filters

When shooting colour transparency film, the Wratten 81 series of filters together with the 85C will be a tool you turn to on a regular basis. Commonly called **warm up filters**, they are generally yellow in colour and effectively reduce the colour temperature of the lighting in your composition. The yellow colour of these filters will have a dramatic effect on anything blue in your composition – particularly the sky. This effect will generally be unnatural and will scream 'filter' to the viewer of your final print. The warm up filters will have the most beneficial effect if you are photographing in open shade without sky in your composition. Alternatively, they can be successfully employed to warm up an already warm image, although their impact will be less dramatic in such cases.

The 80 and 82 series of blue filters will be less commonly used, simply because it is rare that the lighting in any composition is too warm. We tend to enjoy compositions lit by warmer light; skin tones appear healthier and scenes are more welcoming. They do have their place, however, and subtle applications can help to enhance a blue sky, or ensure a deep blue when photographing bluebells. On stormy days with monochromatic, drama-filled skies, a subtle use of a blue filter can enhance the moody atmosphere.

The most important thing to remember when reaching for your **colour correction filter** is that it will have an impact on the whole scene, not just the component you may wish to address. Using these filters is always a compromise and you need to weigh up the benefits against the disadvantages in each case. Remember that successful images are often all about emotion, mood and ambience. The colour of the light source is usually a key contributor to obtaining these successful images and sharing those emotions with the viewer. Don't be in a rush to filter it away.

colour correction filter/colour conversion filters the Wratten 80 series of filters that are used to convert a light source of one colour temperature to that expected by the film
warm up filters the Wratten 81 series of filters, which reduce the apparent colour temperature

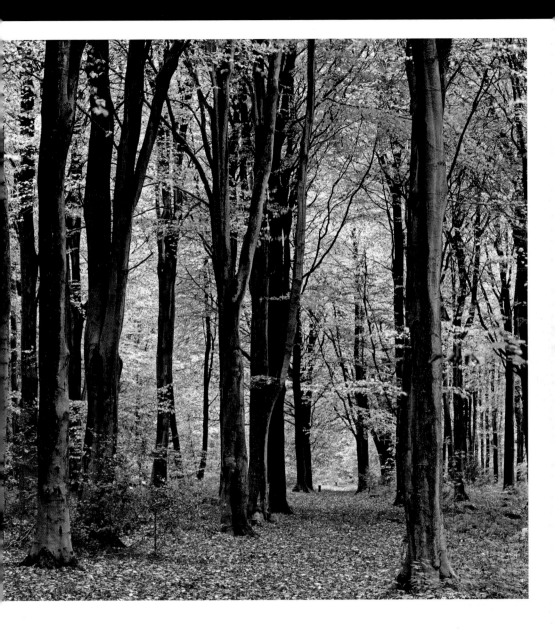

West Woods near Marlborough, Wiltshire

The colours in this composition were already quite warm, but the sky was fairly overcast. In order to emphasise the autumnal feel a Wratten 81C yellow warm up filter was employed.

Photographer: Phil Malpas.

Technical summary: Ebony 45SU 4x5 field camera with Nikon Nikkor M 300mm f9 lens, exposure 4 seconds at F32, Fuji Velvia 50 rated at ISO 50, with Wratten 81C.

The following images were taken using a Mamiya RZ67 camera and Fuji Velvia 50 film. The subject is the magnificent San Biagio in Montepulciano, Tuscany, Italy. This is a good subject for judging the impact of the warm up filters, because the stonework of the church is pale enough to see the filter's effects clearly. More subtle changes happen in the foreground foliage, but the major impact is in the sky. In the last images in the series, with the Wratten 85C in place, the sky has turned a horribly unnatural colour. The beautiful blue has changed to a muddy brown and the clouds have turned an orange/pink colour.

No filter

Wratten 81C

Wratten 81D

Wratten 81A

Wratten 81B

Wratten 81EF

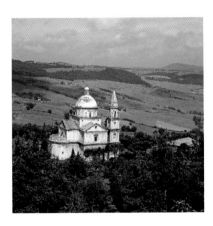

Wratten 85C

San Biagio, Montepulciano, Tuscany, Italy

The wonderfully warm sandstone of the Chiesa di San Biagio in Montepulciano can benefit from some extra warmth through the use of filtration. Care needs to be taken as the filter will affect the whole image including the sky.

Photographer: Phil Malpas.

Technical summary: Mamiya RZ67 camera with Mamiya 110mm f2.8 lens, exposure varies based on filter factors, Fujichrome Velvia 50 rated at ISO 50, Aperture Priority, filtration as captioned.

Neutral density filters

In order to maximise the saturation of colours in our compositions, it is important to control the subject brightness range to a level that can be successfully captured by our film or digital camera. Subject contrast is the enemy of colour photography, as the addition of white or black to the colours of the subject weakens the pureness of the hues present and as a result reduces colour contrast.

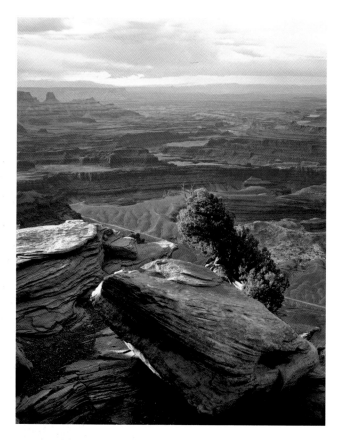

Dead Horse Point State Park, Utah, USA

The addition of four stops of ND Grad (three stops down to the horizon and one stop down to the tree) has allowed the film to capture full detail throughout the image.

Photographer: Phil Malpas.

Technical summary: Ebony SV45TE 4x5 field camera with Schneider Apo-Symmar 150mm f5.6 lens, exposure 6 seconds at F32, Fuji Velvia 50 rated at ISO 50, filtration 0.9 ND Grad soft and 0.3 ND Grad soft.

Neutral density graduated filters (ND Grads) are a key tool in colour photography, and yet their use is often misunderstood. Both film and digital cameras are only capable of capturing a limited contrast range and any parts of the subject that fall outside this range will lack detail and colour saturation. The ND Grad is the tool we use to overcome subject contrast.

The brightness range that a film or digital camera can record varies and different photographers may disagree as to how big this range is. Generally, two stops either side of the exposure is acceptable. Anything more than two stops brighter or darker than the chosen exposure will appear either as featureless white or solid black respectively.

Dead Horse Point State Park, Utah, USA

Without the ND Grad filters to hold back the exposure, the top of the image is hopelessly over exposed.

Photographer: Phil Malpas.

Technical summary: Ebony SV45TE 4x5 field camera with Schneider Apo-Symmar 150mm f5.6 lens, exposure 6 seconds at F32, Fuji Velvia 50 rated at ISO 50, filtration none.

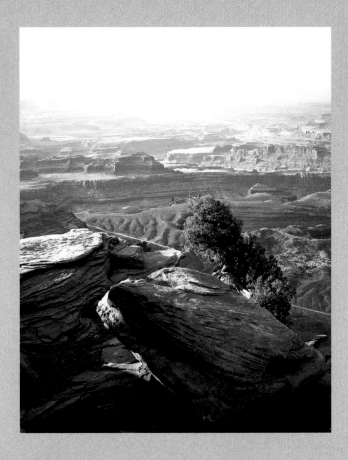

neutral density used in relation to filters that contain no colour. These filters are used purely to affect exposure and will not produce a colour cast

Dealing with contrast

When confronted with a composition where the subject brightness range exceeds these levels, you are left with three choices: allow part of your image to be over exposed and record as featureless white; allow part of your image to be under exposed and record as solid black, or use an ND Grad filter to reduce the contrast range.

When aiming for ultimate image quality, it is important to avoid filters designated as grey grads as these can result in a colour cast in the final image. True ND Grads are completely colourless; they only contain neutral density and will not change the colour of the final image. All ND grads consist of an optically clear material, part of which is completely clear and part of which has neutral density added. Between these two regions of the filter is the graduated area, where the density gradually changes from clear to the same as the area containing density.

There are two main types of ND Grad available: circular filters that screw on to the front of the lens, and rectangular filters that fit in some form of filter holder. Of these, the rectangular type are the best option as the area of graduation can be moved relative to the lens.

All good quality ND Grads are specified with a particular value in stops. This value refers to the amount of light that the fully dense part of the filter cuts out. For example, a one stop ND Grad will allow twice as much light through its clear portion as it will through its dense portion. The terminology used to define the number of stops the filter will cut out is as follows:

0.3 ND Grad = one stop of density

0.45 ND Grad = one and a half stops of density

0.6 ND Grad = two stops of density

0.75 ND Grad = two and a half stops of density

0.9 ND Grad = three stops of density

In each case, there are two types available: soft and hard. The **soft filters** simply have their graduated area spread out further than the **hard filters**. Hard grads are more useful to the 35mm user, because relative to the film size, the graduated area can be more accurately placed. Those using medium or large format cameras may find it easier and less likely to be visible if they use the soft version.

hard filters graduated filters in which the area of graduation extends across a smaller portion of the filter
soft filters graduated filters in which the area of graduation extends across a larger portion of the filter

The bottom half of this one stop grad (0.3) lets through twice as much light as the top

The bottom half of this two stop grad (0.6) lets through four times as much light as the top

The bottom half of this three stop grad (0.9) lets through eight times as much light as the top

This three stop grad has a softer transition between the dense and clear parts of the filter

In order to use these filters successfully, you will need to be able to take meter readings from different parts of your subject. The ideal tool for this is a hand held spot meter, but you can manage perfectly well with a through-the-lens spot meter as supplied on most modern SLRs. Digital users can avoid the metering by adopting a trial-and-error approach and using the histogram function to check results on location (although the techniques described here will allow you to get it right first time!).

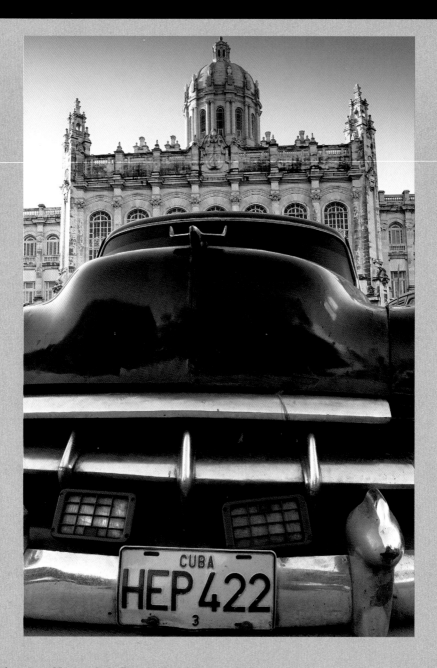

American car, Museo de la Revolución, Havana, Cuba
Due to the bright sunlight on the museum and the dark colour of the car, seven and a half stops of ND Grad were required in order to retain detail in both.

Photographer: Phil Malpas.

Technical summary: Canon EOS 10D with Canon 17–40mm f4.0L USM at 20mm, Aperture Priority, exposure 1 second at F22, ISO 100 with 0.9 (3 stop) 0.75 (2.5 stop) and 0.6 (2 stop) ND Grads (hard).

Using ND Grads effectively

Imagine that you are by the coast, and set up a composition with fantastic rocks in the foreground and a beautiful sky in the background. You take meter readings from the darkest parts of the foreground and the brightest parts of the sky and find that there is a six stop difference. Using your chosen aperture, you find that the meter reading from the darkest rocks is one second and from the brightest sky is 1/60th second. If the shutter speed is set to 1/4 to ensure that the detail in the darkest rocks will record successfully then the brightest areas of the sky are now four stops above the chosen exposure and will record as featureless white. Conversely the shutter speed could be set to 1/15th to rescue the sky, but this would result in the darkest rocks appearing as solid black causing the wonderful detail to be lost.

The answer is to completely ignore the sky in the initial calculations. Readings should be taken from the darkest and brightest parts of the foreground. As before, the rocks give a reading of one second and the reflection of the sky in the rock pools gives a reading of 1/8th second. We now know that by setting our shutter speed to 1/4, both these areas will record with full detail. By employing a 0.6 (two stop) ND Grad over the sky, its brightness is reduced and therefore the time required to expose correctly is increased. The unfiltered 1/60th second becomes 1/15th second with the filter in place and now all parts of the composition fit nicely into the two stops range and will be fully saturated with colour and show all the wonderful detail that was intended to be captured.

Effectively the 0.6 ND Grad has been used to reduce a subject brightness range of six stops to one of just four stops. The overpowering influence of black and white on the colours in the composition has been reduced and the true colours of the subject revealed.

American car, Iglesia del Santo Angel Custodio, Havana, Cuba

Surprisingly, for this image nine stops of ND Grad were required. This was achieved after a number of failed attempts with less filtration. One of the advantages of the digital approach is the ability to check the histogram after each exposure.

Photographer: Phil Malpas.

Technical summary: Canon EOS 10D with Canon 17–40mm f4.0L USM at 27mm, Aperture Priority, exposure 1/25 second at F8, ISO 100 with 0.9 (3 stop) 0.75 (2.5 stop) 0.6 (2 stop) and 0.45 (1.5 stop) ND Grads (hard).

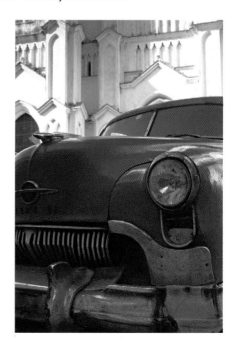

Polarising filters

Polarising filters can greatly enhance our images, but unless we fully understand how they work, what effect they might have and whether any effect is likely to be beneficial, there is potential to ruin an otherwise successful result.

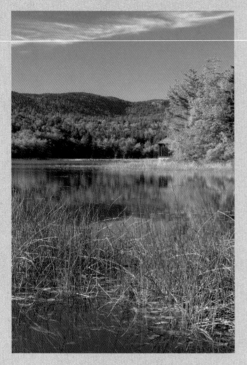

1) With polariser

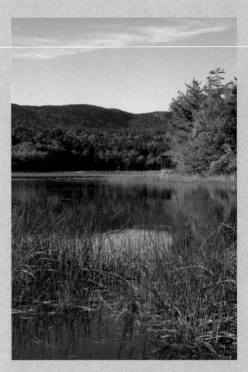

2) Without polariser

Little Long Pond, Acadia NP, Maine

These two images demonstrate what an amazing difference a polarising filter can make. The sky becomes darker, there are less reflections in the water and the colour of the foliage is more deeply saturated. Notice the different shutter speeds – the polariser blocks out two and a half stops of light.

Photographer: Phil Malpas.

Technical summary: 1) Canon EOS 10D with Canon 28–135mm f3.5–5.6 IS at 60mm, Aperture Priority, exposure 1/4 second at F22, ISO 100 with Heliopan 105mm warming polariser.

2) Canon EOS 10D with Canon 28–135mm f3.5–5.6 IS at 60mm, Aperture Priority, exposure 1/25 second at F22, ISO 100, no filtration.

There are two main situations when the polariser will be useful. Both involve the removal of partially polarised light, which appears as glare. When light travels through the atmosphere, the light waves are scattered by collisions with electrons, which partially polarises the light, resulting in a 'washed out' sky. Similarly, non-metallic surfaces will reflect light that vibrates in the direction parallel to the reflecting surface as partially polarised light. This appears as glare and can prevent the viewer from seeing the true colour of the surface beneath.

Polarising filters are able to block all light that vibrates in any but the specific plane they allow through. So when unpolarised light hits the filter, it emerges at a lower intensity and with all the vibrations in a single plane – i.e. as polarised light. It is probably easiest to picture the filter as being a bit like a grating. Any light waves vibrating at 90 degrees to the bars of the grating are blocked out. The alignment of the 'grating' is known as the **polarisation axis**. By rotating the filter in front of the lens we can select which light is allowed through and which is blocked.

Autumn colour, Vermont, USA

Here the polariser has cut out light reflected from the surface of these autumn leaves, allowing the spectacular colours underneath to shine through.

Photographer: Phil Malpas.

Technical summary: Canon EOS 10D with Canon 28–135mm f3.5–5.6 IS at 50mm, Aperture Priority, exposure 1/50 second at F10, ISO 100 with Heliopan 105mm warming polariser.

polarising filter a specialised filter that has the ability to block partially polarised light. It has the effect of darkening skies and reducing reflections
polarisation axis the alignment of molecules in a polarising filter

Using polarising filters

The traditional use of polarising filters is to darken blue skies. In general a polariser will achieve this only if the camera is pointing at 90 degrees to the direction of the sun. If you stand directly behind the camera, facing the direction the camera is pointing, then the polariser will have its maximum effect if the sun is directly to your left or right. If the sun is in front of or behind you, then the filter will have no visible effect other than to act as neutral density and effectively reduce the amount of light coming through the lens.

Care must be taken when using extremely wide angle lenses. This is because the angle of view that these lenses cover can extend over a large percentage of the sky and, as such, the polarising effect of the filter will be different across the width of the image. Care must also be taken not to over-polarise. Modern films tend to be particularly sensitive to polarised light and this can result in skies that are rendered as deep navy or even approaching black, which can be completely unnatural.

There is no need to actually mount the polarising filter on the lens to see the effect it will have, you can simply hold it in front of your eyes and view your scene whilst rotating one of the two rings. This is a good habit to adopt because it teaches you to anticipate how the filter will work in different situations. If you are out in the field on a photographic trip, make a point of taking your polariser out and looking through it in different directions relative to the position of the sun to see how the effect changes.

One key factor is the filter thread size. If you own a number of different lenses that take different sized filters, then you will be forced to buy separate polarisers for each lens. This can be very expensive. An alternative is to purchase a single over-sized filter that can cover all your lenses, such as those offered by Lee Filters and Heliopan. These filters are designed to fit on to a filter holder that has the advantage of fitting to each of your lenses by a separate (relatively cheap) adapter. This means that you only need an adapter for each lens, and use the same polariser for all of them.

It is important that you familiarise yourself with your filter; not only what effect it might have in differing conditions, but also how it will affect your exposure depending on how, where and when you use it. Most importantly do not over do it – keep it subtle and this filter will become a key part of your photographic armoury.

Lee Filters 105mm polariser with adapter

The Lee 105mm polariser can be used with the adapter shown to cover all your lenses.

When calculating exposure, those with through-the-lens meters can allow the camera to adjust automatically. If you use a hand held meter, then you will need to make a manual adjustment for the filter's effect. The key thing to remember regarding exposure is that the filter will block differing amounts of light and therefore require different adjustments depending on the amount of rotation (and therefore polarisation) you apply. It should come as no surprise therefore that you will need to practise with your filter and keep detailed notes, if you wish to confidently predict your results and make correct exposures.

Lee Filters filter holder, showing 105mm front ring

The Lee Filters filter holder can be tailored to suit the photographer's particular requirements.

It is important to realise that all polarising filters are different, in that they may differ in colour, the amount of light that they block, the thread size for attaching to different lenses, and even the thickness (thinner filters are better at avoiding vignetting with wide-angle lenses).

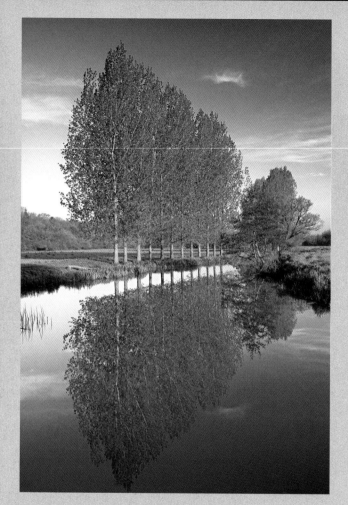

Little Somerford, Gloucestershire

The angle of the sun, being at 90 degrees to the direction in which the camera is pointing, has maximised the polarising effect.

Photographer: Phil Malpas.

Technical summary: Canon EOS 10D with Canon 17–40mm f4.0L USM at 21mm, Aperture Priority, exposure 1/2 second at F22, ISO 100 with Heliopan 105mm warming polariser.

Fishing boat, Mondello, Sicily (facing opposite)

The polariser has served to give deep, rich, saturated colours by removing any reflections in the paintwork. It has also deepened the shadows and the blue sky resulting in higher contrast. One thing to note is that the 90 degree angle necessary for a polariser to work can sometimes be achieved by pointing the camera upwards.

Photographer: Phil Malpas.

Technical summary: Canon EOS 10D with Canon 17–40mm f4.0L USM at 17mm, Aperture Priority, Exposure 1/640 second at F6.3, ISO 100 with Heliopan 105mm warming polariser.

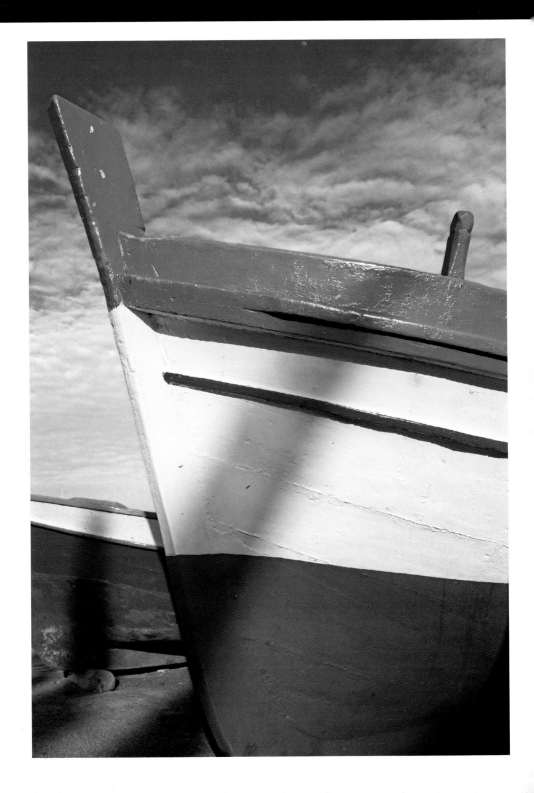

Artificial light

When photographing subjects illuminated by artificial light, there are a number of technical hurdles that you need to address. Firstly, it is likely that the brightness of the illumination will be lower than daylight and so you will need to use a fast film speed, a wide aperture, or a long exposure. Even though many modern cameras have options for image stabilisation, these will only be of benefit on slightly longer exposures than you can hand hold. A general rule of thumb is that in order to get sharp pictures when working hand held, you should use a shutter speed that is at least one over the focal length of the lens you are using. So, if your composition requires a 210mm lens then you need to shoot with a shutter speed of 1/250 second or faster. If you are using a wide-angle lens, such as a 28mm, you should be successful at 1/30 second. An image stabilisation option may allow you to use a shutter speed that is up to two stops slower successfully, but if at all possible, the better approach is to mount your camera on a tripod and switch the image stabilisation off.

There are many high quality fast films on the market that can give acceptable results, particularly in the ISO 400 bracket. If you are shooting digitally then you can change the film speed on your camera directly. Many modern DSLRs will cope very well up to ISO 400 but if you push the speed any higher you may find that your images become noisy due to issues with the camera's ability to amplify the low light levels up to a point where it can make an acceptable image. Using wide apertures is an option, although you may be restricted by the depth of field you require to ensure that the important parts of the image are sharp. This combination of low light levels, medium film speed for quality and a small enough aperture to offer sufficient depth-of-field result in two possible scenarios. You will either need to use a long shutter speed or you will have to introduce some light using electronic flash.

Electronic flash is balanced for daylight and will not require any additional filtration for colour balance as long as you are using daylight film, or you have your digital camera set either on daylight or auto white balance. There are many occasions, however, where flash will not be an option, mainly when the subject you are photographing is a long way away. When your subject is architecture, city scenes, low light landscapes or large building interiors, you will have to use the available lighting. In these cases you will need to take into account the colour of the available illumination as it is unlikely to be daylight balanced. You may still choose to use electronic flash to light objects that are relatively close to the camera, an approach known as fill-in flash. The problem then is that you will need to deal with mixed light sources, some of which will be daylight balanced and some of which will not.

The colour temperature of a light source describes how blue or how red it is. Photographic colour temperature can be compensated for by using the Wratten series of colour temperature filters when you are using film, or by using the white balance control when shooting digitally. The key here is that either of these approaches will only affect your image in the blue to red range, and cannot address how green a light source might be. Many artificial light sources will cause a colour shift between green and magenta and an alternative method of filtration is therefore required.

Colour compensating filters are used to make changes in the colour temperature of the light that illuminates a particular scene to match it to the colour balance of the film or digital camera. Filters are available in primary (red, green, blue) or secondary (cyan, magenta, yellow) colours. By convention these filters are called **CC filters** and their names reflect their density and colour. For example, a CC30M is a magenta filter with a density of .30, or one f-stop, and the CC20G is a green filter with a density of .20, or 2/3 of an f-stop.

The light output from fluorescent tubes can rarely be corrected using colour temperature filters and will usually require an amount of yellow or magenta filtration. If left unfiltered, fluorescent tubes will generally result in a green cast to the image, which can sometimes be very appealing. If true neutral colour is required, you will need to obtain and utilise the appropriate filters. A number of manufacturers sell colour compensating filters in the form of gels for each of the primary and secondary colours. It is possible to achieve the effect of a primary coloured filter by using two of the secondary coloured filters, for example 10 magenta plus 10 yellow is the equivalent of 10 red. These filters can also correct colour shifts in film due to reciprocity failure. When using Fuji Velvia 100, for example, the addition of a 025 magenta filter is recommended for exposures longer than two minutes.

Lee Filters Colour Compensating (CC) Filters and their associated exposure adjustments

Filter intensity designation									Principal effect
025	05	10	15	20	25	30	40	50	
Cyan Nil	1/3	1/3	1/3	1/3	1/3	2/3	2/3	2/3	Absorbs red
Yellow Nil	Nil	1/3	1/3	1/3	1/3	1/3	1/3	1/3	Absorbs blue
Magenta Nil	1/3	1/3	1/3	2/3	2/3	2/3	1	1	Absorbs green
Red Nil	1/3	1/3	1/3	2/3	2/3	2/3	1	1	Absorbs blue and green
Green Nil	1/3	1/3	1/3	1/3	1/3	1/3	2/3	2/3	Absorbs blue and red
Blue Nil	1/3	1/3	1/3	2/3	1	$1^{1/3}$	$1^{1/3}$	$1^{2/3}$	Absorbs red and green

Some filter manufacturers also offer specialist filters that are designed to compensate for a specific type of lighting. Filters can be obtained for lighting such as high pressure sodium and daylight balanced fluorescent tubes.

CC filters colour compensating filters that are used to match the colour of a light source to that expected by the film

Controlling the colour of a light source

Lighting type	Filter code	Film type	Filter factor	Light source
Arc	HPS-B	Tungsten (3200k)	2 Stops	High-pressure sodium
Arc	MV-B	Tungsten (3200k)	2 Stops	Mercury vapour
Arc	HPS-D	Daylight (5500k)	3 Stops	High-pressure sodium
Arc	MV-D	Daylight (5500k)	2 1/3 Stops	Mercury vapour
Fluorescent	FL 5700-B	Tungsten (3200k)	1 1/3 Stops	Cool white 5700k
Fluorescent	FL 4300-B	Tungsten (3200k)	1 Stop	White 4300k
Fluorescent	FL-3600-B	Tungsten (3200k)	2/3 Stop	Warm white 3600k
Fluorescent	FL-5700-D	Daylight (5500k)	2/3 Stop	Cool white 5700k
Fluorescent	FL-4300-D	Daylight (5500k)	1 Stop	White 4300k
Fluorescent	FL-3600-D	Daylight (5500k)	1 2/3 Stops	Warm white 3600k

If controlling the colour that a light source will appear is critical, then you will need to perform some test exposures to ascertain the correct filtration. It is possible to purchase a meter called a **colour temperature meter** that can be used much like an exposure meter, but to calculate the precise colour in terms of the red, green and blue that a light source emits. This then indicates the filtration you need to employ to arrive at a neutral result. Colour temperature meters are very expensive and are unlikely to be economical unless this type of photography is a core part of your work.

An alternative approach is to accept that some artificial light sources will cause a colour shift, and to post process your scanned film or digital file in an image editing program. Adobe Photoshop, for example, has all the tools necessary for selectively adjusting the colour of an image regardless of the colour cast present.

In some cases you will be faced with mixed lighting conditions where different parts of your subject are lit by light sources of different colours. In these situations there are two alternatives. Firstly, you could filter some of the actual lights to make them all the same colour and balance the remaining colour with filtration. The alternative is to simply accept the colour shifts and try to compose your image in such a way that the various light sources add to your final image from a creative viewpoint.

Architecture using mixed light sources (facing opposite)
The subject here is lit by light sources of varying colour, including the last remnants of daylight. This would have been very difficult to correct using filtration and instead the different colours of illumination were allowed to enhance the richness of the image.

Photographer: Phil Malpas.

Technical summary: Ebony SV45TE 4x5 field camera with Schneider Super-Angulon 90mm f8 lens, exposure 1 second at F22.5, Fuji Velvia 50 rated at ISO 50, no filtration.

colour temperature meter a meter that measures the colour of a light source in kelvins

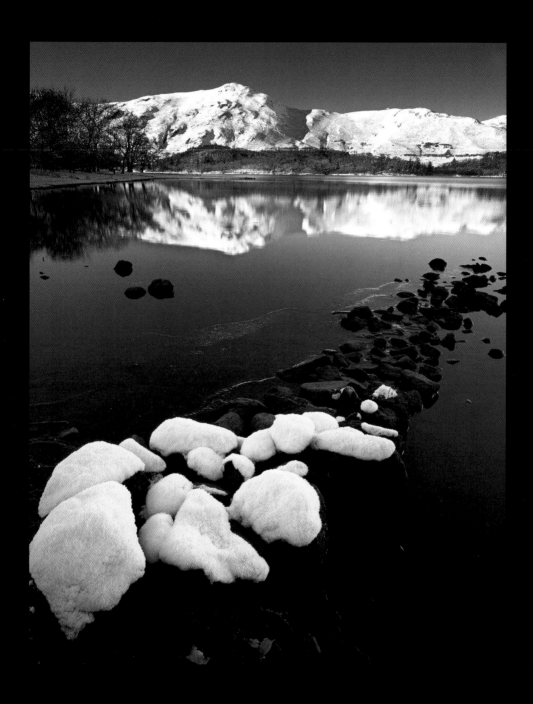

This section contains images that may help you to define your own approach to using colour effectively. Colour can of course be used in an infinite variety of ways. We can choose to almost remove it completely, we can use strong bold colours to give our compositions impact or we can choose only certain colours that work well together.

Colour can have a powerful emotional impact, as the British psychoanalyst Marion Milner observed – 'Colour is, on the evidence of language alone, very bound up with feelings'. How many songs have your heard that refer to 'feeling blue'? Is it not possible to be 'green with envy' and when anger takes over are we not described as 'seeing red'? Using colour to express emotion is a key marketing technique, we often see advertisements for a healthy, happy lifestyle that always use brightly dressed young models in bright sunny conditions. We are surrounded by images that are designed to sell us something, tens of thousands of new images are created each day just for this purpose.

Colour can be a key tool in giving the viewer information about time. The colour of light gives us a clear indication as to the time of day, and night or low light photography can result in highly saturated bold colours. Foliage colour gives us information about the seasons; fresh, bright greens speak of spring and then there are all the wonderful reds and browns associated with autumn.

There is only space for a few images here, but they should give you an insight into how to analyse and appreciate the use of colour in the imagery that is all around us. Take note of what you learn from other people's images, and resolve to make bold, imaginative colour statements in your own work.

Derwentwater from near Kettlewell
The cold blue light illuminating this scene works well to enhance the feeling of winter. In such circumstances you should not use any form of warm up filter and if shooting digitally you may need to adjust your white balance away from the value selected by the auto white balance function.
Photographer: Phil Malpas.
Technical summary: Ebony SV45TE 4x5 field camera with Schneider Apo-Symmar 150mm f5.6 lens, exposure 4 seconds at F32, Fuji Velvia 50 rated at ISO 50, with 0.3 (1 stop) ND Grad (soft).

Limiting the colour palette

An excellent way to use colour is to limit the number of hues within your composition. Single colours can deliver a far more powerful message when they do not have to compete for the viewer's attention. An alternative is to select a limited palette of colours, by carefully choosing your viewpoint to omit certain elements from your image. Often what you leave out is just as important as what you keep in. If you intend to sell prints of your work, images where there is a coherent colour scheme are likely to be more saleable, simply because they will fit better with the buyer's chosen colour scheme. Try to develop an approach to composition where you consistently consider not only the physical elements of your subject, but also the colours of those elements as well.

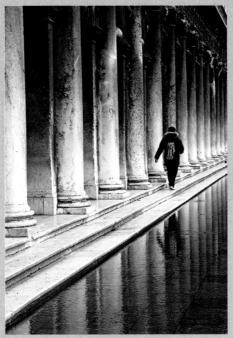

San Marco, Venice, Italy

This image was taken on a cold January day in San Marco, when Venice was in the grip of the Aqua Alta. I had set up to make an image of the columns and their reflections in the flood waters. The figure in the scene was unplanned. His presence is all the more striking because, apart from his bright yellow rucksack, most of his clothes are as colourless as his surroundings. This image may have the appearance of being digitally desaturated, but it is completely un-manipulated. The yellow rucksack and its reflection occupy a small part of the frame and yet they are a powerful part of the composition.

Photographer: Phil Malpas.

Technical summary: Canon EOS 10D with Canon 28–135mm f3.5–5.6 IS at 150mm, Aperture Priority, exposure 1/160 second at F9, ISO 100, no filtration.

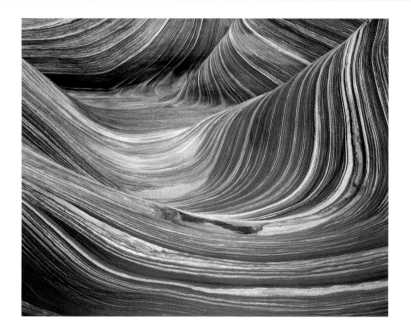

The Wave, Colorado Plateau, USA

In this composition of these spectacular rock formations the sky has been removed completely. By restricting the colour palette to just warm hues, the viewer's eye is free to roam throughout the frame in a far more relaxed manner than it would had the sky been included in the frame. It can sometimes be interesting to remove all points of reference from an image, leaving the viewer to decide the scales involved. The removal of the horizon line promotes the question as to whether these formations are tens or hundreds of feet high.

Photographer: Phil Malpas.

Technical summary: Ebony SV45TE 4x5 field camera with Schneider Apo-Symmar 150mm f5.6 lens, exposure 1/15 second at F32, Fuji Velvia 50 rated at ISO 50, no filtration.

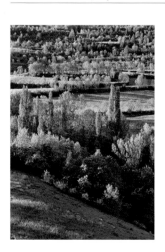

Backlit trees near Montella, the Pyrenees

This view of the foothills near Montella in the Spanish Pyrenees is striking because anything that might possibly compete with the stunning springtime greens of the backlit trees has been excluded. This not only includes the sky, but also some buildings, walls and yellow flowers just out of frame. Seemingly infinite shades of a single hue can sometimes have a greater impact than a multitude of different hues.

Photographer: Phil Malpas.

Technical summary: Ebony 45SU 4x5 field camera with Nikon Nikkor M 300mm F9 lens, exposure 4 seconds at F32.5, Fuji Velvia 50 rated at ISO 50, with Heliopan 105mm warming polariser.

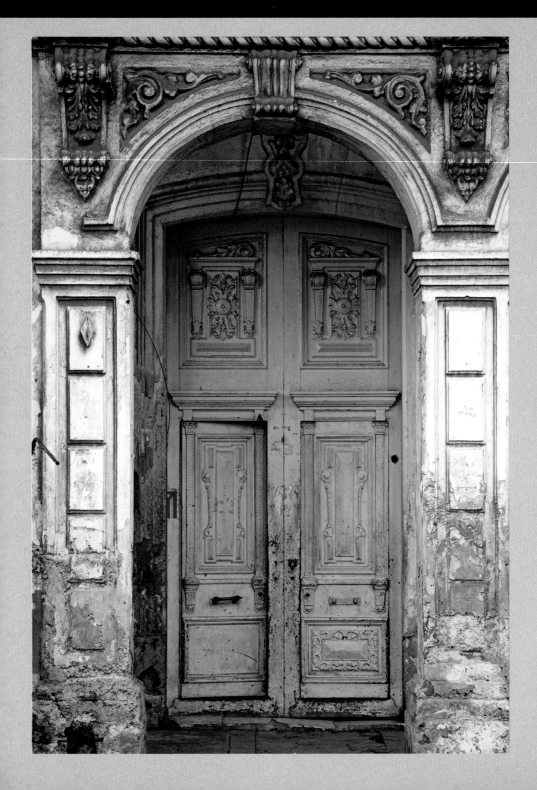

The Prado, Havana, Cuba (facing opposite)

When searching for subject matter try and cultivate an ability to see compositions where the colour palette contains only one or two colours. In this case the buildings immediately to the left and right of this doorway were brightly coloured, and so I chose to concentrate on the single door with its ageing appearance. In fact the only tiny splash of colour in this image is that of the Cuban flag, which places the subject nicely.

Photographer: Phil Malpas.

Technical summary: Canon EOS 5D with Canon 28–135mm f3.5–5.6 IS at 105mm, Aperture Priority, exposure 1.3 seconds at F18, ISO 50, no filtration.

The Grand Canal, Venice, Italy (below)

The palette here consists of the group of analogous colours on the warm side of the colour wheel. Taken at the end of the day, the warm evening light is significantly lower than the colour temperature the film requires, resulting in any cool colours being overpowered. This type of lighting creates a timeless atmosphere that would be lost in a similar picture taken earlier in the day.

Photographer: Clive Minnitt.

Technical summary: Canon EOS 1 with Canon 75–300 f4–5.5 USM lens at 300mm, Aperture Priority, exposure 1/30 second at F16, Fuji Velvia 50 rated at ISO 50, with Wratten 81B.

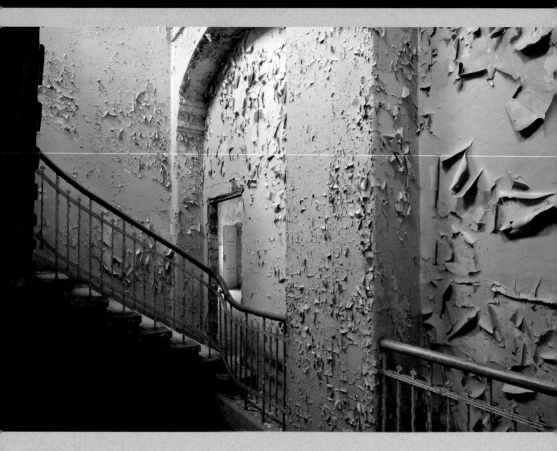

Beelitz Sanatorium

Guido's amazing image of the Beelitz Sanatorium is incredibly mysterious. The image challenges the viewer to imagine just what this institution must have been like in its prime. Up until its abandonment in 1994 this building was known as the largest and best equipped military hospital and medical education centre outside the Soviet Union. By focusing on the peeling paintwork in this stairwell, Guido removes the confusion that multiple colours may have caused and forces us to concentrate on the big questions; asking ourselves exactly what went on here?

Photographer: Guido Steenkamp.

Technical summary: Canon EOS 5D with Canon 17–40mm f4.0L USM at 22mm, Aperture Priority, exposure 8 seconds at F22, ISO 50, no filtration.

Bronze Daisies

This beautiful image of the bronze daisies demonstrates how effective limiting the palette of an image can be. When arranging her composition, Sue has gone to great lengths to ensure that the background to the main subject is filled with the same colour as the featured blooms. Even though the limited depth of field has rendered the background completely out of focus, the large areas of colour imply a host of other flowers whilst concentrating the viewer's attention on the main subject.

Photographer: Sue Bishop.

Technical summary: Nikon F3 with Nikon Micro Nikkor 200mm f/4 D lens, Aperture Priority, exposure 1/60 second at F4, Fuji Velvia 50 with Wratten 81B.

Scilla

As with the image of the daisies, Sue has once again limited the colour palette to great effect.

Photographer: Sue Bishop.

Technical summary: Nikon D1X with Nikon Micro Nikkor 105mm AF-D lens, Aperture Priority, exposure 1/125 at F6.3, no filtration.

Colour for impact

There are a number of ways to use colour to add extra impact to your images. Compositions that use the techniques discussed in the section on colour theory can maximise colour contrast by only including hues from opposite sides of the colour wheel. Alternatively, small accents of colour in otherwise colour-free compositions can direct the viewer's attention towards the focal point. Strong, bold, saturated hues will always have a greater impact than weak, pastel colours. Try to think about the way that colours appear within the frame and how they can enhance the viewer's experience.

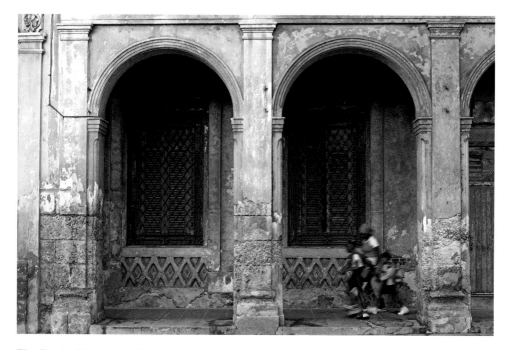

The Prado, Havana, Cuba

The entry of these figures into the frame was not a matter of fortune. I set the camera up in order to frame these two arches, allowing the subdued colour palette to benefit from a punctuation mark of action. At this time of the morning school children rush along The Prado to reach their school, which is only a few hundred yards away. It was just a matter of waiting for a suitable grouping with their brightly coloured uniforms to enter stage right.

Photographer: Phil Malpas.

Technical summary: Canon EOS 10D with Canon 17–40mm f4.0L USM at 38mm, Aperture Priority, exposure 1/20 second at F8, ISO 100, no filtration.

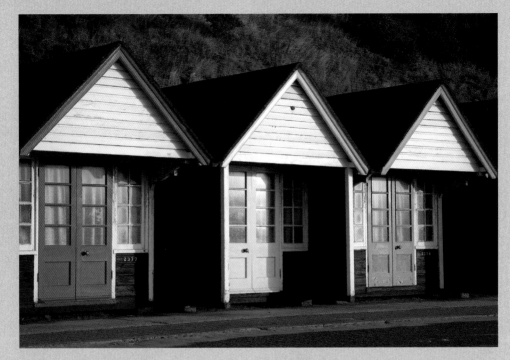

Beach Huts, Bournemouth seafront (above)
In order to maximise the colour contrast in this image, these three beach huts were selected because they are painted in the primary colours from the artist's colour wheel. Had two of the huts been red and one blue, the impact of the shot would have been reduced.

Photographer: Phil Malpas.

Technical summary: Canon EOS 5D with Canon 28–135mm f3.5–5.6 IS at 85mm, Aperture Priority, exposure 1/10 seconds at F16, ISO 50, no filtration.

Casa Mila, Barcelona (above right)
In this view of these spectacular chimney pots on Gaudi's Casa Mila in Barcelona, there is nothing in the frame that does not need to be there. This allows for focus on the colour contrast between the deep blue sky and the terracotta of the chimneys; two colours that are almost opposite on the colour wheel.

Photographer: Phil Malpas.

Technical summary: Nikon Coolpix 995 (compact) digital camera at 9mm, Aperture Priority, exposure 1/184 second at F 5.2, ISO 100, no filtration.

Bluebells, West Woods, Marlborough

Here, the dazzling, lime green of the leaves is contrasted against the deep blue of the flowers to maximum potential due to the low level branch floating on the gentle breeze. A still overcast day was vital here as bluebells are extremely difficult to photograph in sunshine. In direct sunlight, they reflect large amounts of infrared, which can make them appear pink or purple to the film or digital chip.

Photographer: Phil Malpas.

Technical summary: Ebony 45SU 4x5 field camera with Nikon Nikkor M 300mm F9 lens, exposure 1/2 second at F16, Fuji Velvia 50 rated at ISO 50, no filtration.

Car and school bus, Havana, Cuba

When working in a busy city, opportunities for successful photographs may only be available for a matter of seconds. Working quickly, Clive was able to contrast this red car with a yellow license plate against the yellow bus with the red stop sign. The strong, bold, saturated colours create a bright and lively image with a simple yet powerful colour palette.

Photographer: Clive Minnitt.

Technical summary: Canon EOS 1 with Canon 75–300 f4–5.5 USM lens at 250mm, Aperture Priority, exposure 1/2 second at F22, Fuji Velvia 50 rated at ISO 50, no filtration.

Vinales, Cuba

In this composition the complementary colours of the blue and yellow paintwork add impact to the scene. Unfortunately, the impact is not as strong as it could have been, mainly because the striking blue and yellow are watered down by the brown floor and white ceiling. A better approach may have been to crop in tighter and leave out these unwanted colours, maximising the colour contrast and therefore the impact.

Photographer: Phil Malpas.

Technical summary: Canon EOS 5D with Canon 17–40mm f4.0L USM at 21mm, Aperture Priority, exposure 1/2 second at F22, ISO 50, no filtration.

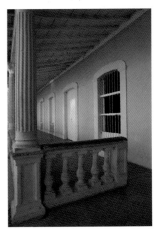

Colour and emotion

The use of colour in a photographic image is an important tool for communicating emotional content to your viewer. The colours from the warm side of the colour wheel will tend to be associated with positive emotions, whilst those from the cool side will favour more sombre and sad feelings. This of course is a fairly general statement and the key contributor to the mood that an image communicates will always be the content itself, but if one of your prime objectives for an image is to share an emotional experience or communicate a particular mood to the viewer, then you should always consider the colour content as a way of reinforcing the message.

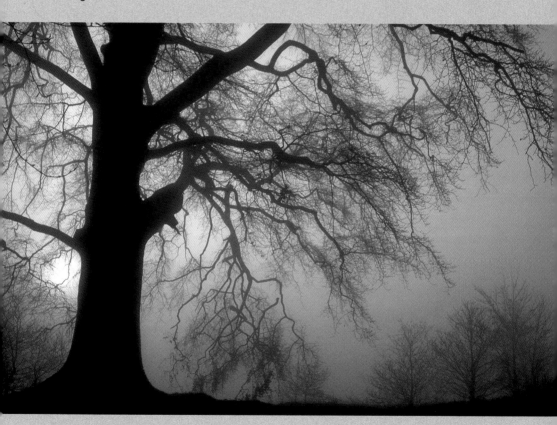

Clumber Park, Nottinghamshire

Weather conditions can always give an image a particular atmosphere. In this shot of Clumber Park in Nottinghamshire, Clive has captured an air of mystery and foreboding that is supported by the almost complete lack of colour. Large trees in winter, particularly when pictured in these conditions, have a magical quality.

Photographer: Clive Minnitt.

Technical summary: Canon EOS 1 with Canon 75–300 f4–5.5 USM lens at 80mm, Aperture Priority, exposure 1/2 second at F16, Fuji Velvia 50 rated at ISO 50, no filtration.

Sadness

For this portrait of a young girl feeling sad, the photographer made a conscious decision to eliminate colour and adopt a duotone approach. The choice of pale purple, being from the cool side of the colour wheel, serves to emphasise the feelings that we know the girl is experiencing. The same shot in full colour would not have the same intensity, and the emotional content would have been reduced.

Photographer: Not known.

Technical summary: None supplied.

Girl and staircase, Cienfeugos, Cuba

When searching for subject matter in a new location, particularly somewhere like Cuba, a good approach is to take a look inside each doorway you come across. I discovered this wonderful staircase inside a non-descript entrance on a busy street. The inclusion of the young girl was unplanned, but her presence changes the mood of the scene, as her brightly coloured clothes and wonderful smile added a feeling of youthfulness and joy. Although she occupies only a small part of the frame, she dominates the emotional content of the composition.

Photographer: Phil Malpas.

Technical summary: Canon EOS 10D with Canon 17–40mm f4.0L USM at 22mm, Aperture Priority, exposure 1/6 second at F11, ISO 100, no filtration.

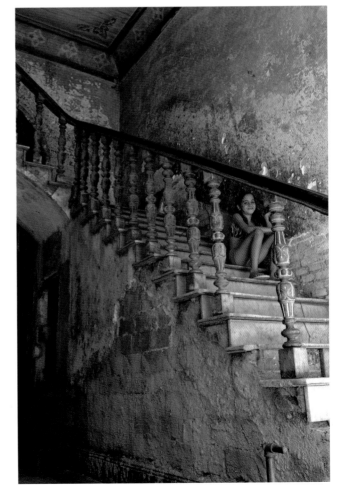

Seascape, Cornwall

The ocean's moods are many and varied, but on a calm day the lapping of the waves can provide an immensely tranquil and peaceful subject. In this image these feelings are emphasised by the cool relaxing colours present on this September dawn in Cornwall. By composing the image straight out to sea, with no foreground rocks, headlands or other distracting details, the palette has been limited to just a few analogous colours.

Photographer: Phil Malpas.

Technical summary: Nikon Coolpix 995 (compact) digital camera at 38mm, Aperture Priority, exposure 1/8 second at F8, ISO 100, no filtration.

Birkrigg Park, Cumbria

In this wintry scene in Cumbria, the colour is very muted and dark supporting the impression that it was extremely cold at the time. Even though the sun is included in the frame, it is very weak due to its low position in the sky and the thin, high cloud cover. It is easy to imagine that the sun is producing little warmth.

Photographer: Phil Malpas.

Technical summary: Canon EOS 10D with Canon 17–40mm f4.0L USM at 33 Aperture Priority, exposure 1/250 second at F5.6, ISO 100, no filtration.

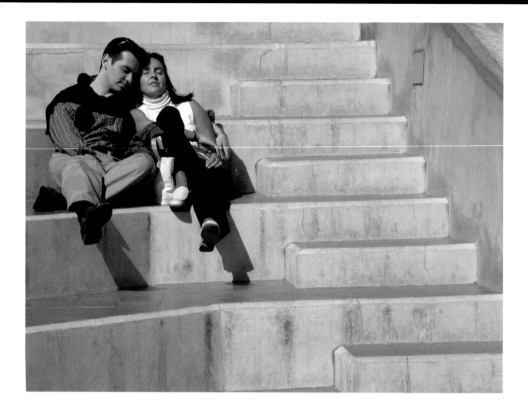

Relaxing couple, Barcelona (above)

This couple on the roof of Gaudi's La Pedrera in Barcelona were completely oblivious to their surroundings. The image is dominated by warm colours, the terracotta steps and the obvious warmth of the sun serve to confirm their contentment in each other's company. They are obviously very happy and in love and this impression is supported by all the elements in the frame, particularly the overall colour balance. A similar image taken in cool coloured or even pure white surroundings would not have delivered the message as successfully.

Photographer: Phil Malpas.

Technical summary: Nikon Coolpix 995 (compact) digital camera at 22mm, Aperture Priority, exposure 1/30 second at F8, ISO 100, no filtration.

Waterfall, Glencoe (facing opposite)

The freezing water in this Scottish waterfall is lit mainly by the clear blue sky above, which enhances its clean, fresh appearance. Waterfalls promote a feeling of peace and tranquillity and photography has a unique ability to capture a period of time through an extended shutter speed that helps to communicate those feelings to the viewer.

Photographer: Phil Malpas.

Technical summary: Canon EOS 5D with Canon EF 100–400 f4.5–5.6L IS USM lens at 220mm, Aperture Priority, exposure 1/4 second at F22, ISO 50, no filtration.

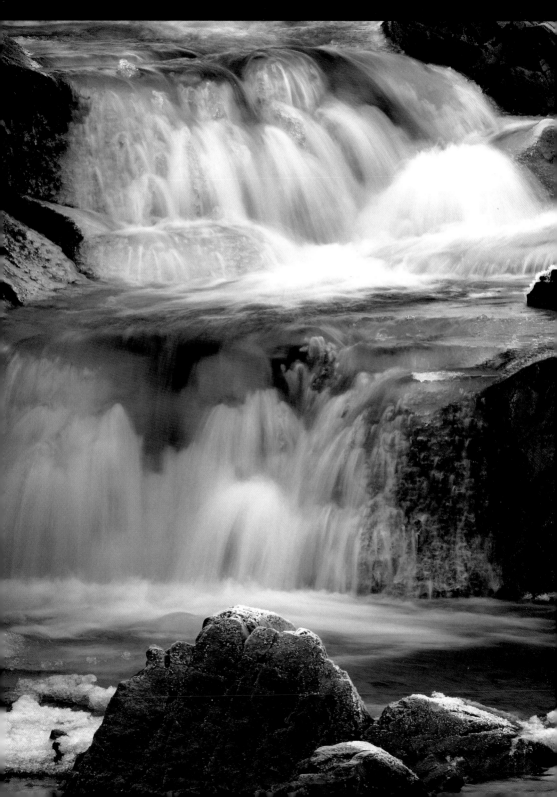

Colour and time

There are a two main ways in which the dominant colour in an image can communicate an impression of time to the viewer. Firstly, with natural light the colour of the light source gives a clear indication of the time of day. At dawn the light has a tendency to be warm, but rarely does it reach the deep reds that might occur at the end of the day. During the day, light becomes cooler. In the middle of the day the colour temperature can be very high and objects tend towards blue, particularly on clear days with little cloud cover.

At temperate latitudes there are many colour-based clues as to the time of year. In springtime, greens tend to be light and vibrant, almost vivid. Many wild flowers such as bluebells, buttercups and daisies will of course indicate an image taken in springtime. In summer the greens become far more verdant with lush, fertile foliage dominating the scene. Possibly the most colourful season of the year is autumn when the landscape transforms itself to the warm russet colours we associate with this time of year. In winter the colours become stark and moody with browns and greys being dominant. Winter colours tend towards the analogous colours on the blue side of the colour wheel with shaded snow and water adopting a blue cast at any time of day. By learning to emphasise these colours we can more clearly communicate with the viewer a sense of atmosphere and time.

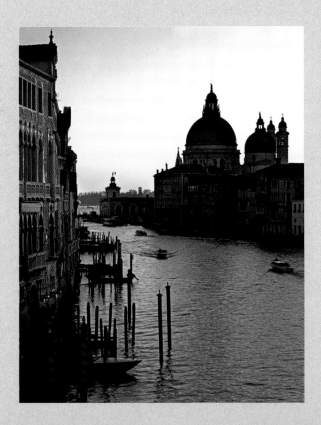

Grand Canal from Accademia, Venice left dawn and right midday

These two views of the Grand Canal in Venice were taken only a few hours apart, yet they clearly demonstrate how the colour of sunlight changes significantly at different times of day. The earlier image was taken at 7am just as the sun rose above the buildings to the right. The warm light bathes the scene and the cloudless sky contains virtually no blue at all. In the second view, taken from the same spot five hours later, blue is the dominant colour and colours from the warm side of the colour wheel are missing. Both of these images were taken in January when even at midday the sun remains relatively low in the sky. Similar images taken in summer would show an even greater difference in the colour.

Photographer: Phil Malpas.

Technical summary: Ebony SV45TE 4x5 field camera with Nikon Nikkor M 300mm F9 lens. Left: Exposure 1.5 seconds at F32, Fuji Velvia 50 rated at ISO 50, no filtration. Right: Exposure 1/4 second at F32, Fuji Velvia 50 rated at ISO 50, with Heliopan 105mm warming polariser.

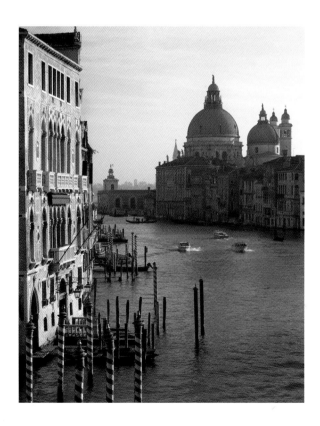

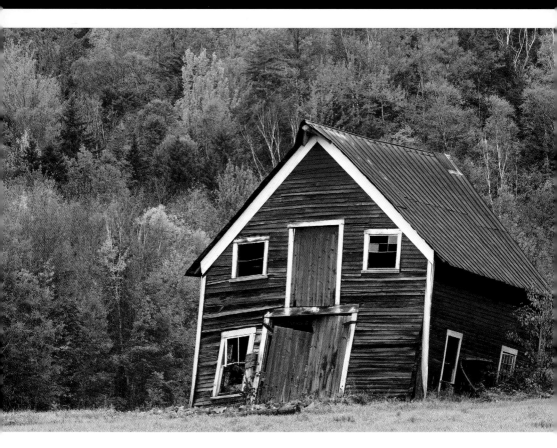

Wonky barn, Vermont USA

This image, taken just north of the state capital Montpelier, is dominated by the warm, analogous colours from the colour wheel. The autumn foliage is a clear indicator of the time of year, but the warm, red colour of the old barn also fits into the same colour scheme. Ensuring that no cool colours appear in the frame helps to emphasise the autumnal feel, an impression which is enhanced by the warm early morning light.

Photographer: Phil Malpas.

Technical summary: Canon EOS 10D with Canon EF 100–400 f4.5–5.6L IS USM lens at 180mm, Aperture Priority, exposure 1/6 second at F22, ISO 100, no filtration.

Wastwater, the Lake District

This series of images by Clive Minnitt were all taken within a 45 minute period on a typical autumnal day. Initially conditions did not look promising for photography as the views were dull and uninteresting due to the lack of direct sunlight. Roughly 15 minutes later a brief shaft of light broke through to illuminate some of the foreground rocks, although this wasn't enough for a dramatic composition. At approximately fifteen minutes before sunset there still wasn't any direct light, but the clouds above the mountains had begun to take on the warm colours associated with the end of the day. Then just five minutes before it was due to set, the sun broke through beneath the clouds to the west and provided this dramatic, theatrical lighting. This final composition clearly demonstrates how warm the colour of light from the sun can be as it crosses the horizon. Just how warm it is, depends on atmospheric conditions.

Photographer: Clive Minnitt.

Technical summary: Canon EOS 1 with Canon EF 16–35mm F2.8 L USM lens at 18mm, exposure 1/15 at F22, Fuji Velvia 50 rated at ISO 50.

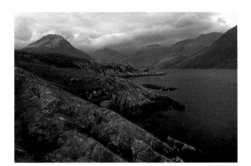

6.15

6.30

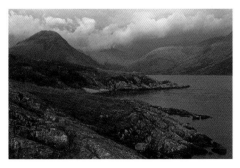

6.45

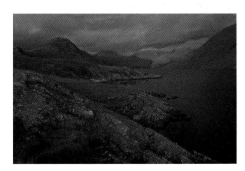

7.00

It is easy to assume that the advent of digital capture has simplified the act of getting your image into a form that you are happy to share with the world. After all there are no films to develop, no chemicals to mix, there is no requirement for a darkroom or a good quality local lab to process your films and prints for you. Although this may be true for the average consumer taking family snapshots, once you have a requirement to produce high quality imagery, the options available to you post-capture are far more complex than they used to be in the analogue world.

The type of digital file that you choose to capture has a significant impact on your ability to take advantage of the post-capture tools available. Many digital cameras will allow you to format your images as JPEGs, RAW or TIFF files, but what exactly are the implications of these choices and which is the right one for you? This section begins by explaining the different format options and how your choice of format can affect your final results.

Once you have captured your images, it is likely that the next stage will be to download them to a computer for further work before progressing to the printing stage. This may be a direct copy from your digital camera, or via a scanner if you shoot on film. There are a number of stages that you will need to go through with each of your images between capture and print. These stages are usually referred to as a 'workflow' and software manufacturers have been working hard to provide photographers with tools that reduce the effort required to progress through this workflow. There are many tools on the market, each of which will approach this requirement in a different way and many of which are featured in the following pages.

The advent of digital imaging has brought the creative side of printing within reach of all of us. The workflow needed to progress from the taking stage through to the fine print has a number of discreet yet interdependent stages, each of which can let down the whole process if not considered properly. Each physical device we use to progress towards our goal will have a different view of colour. The camera/scanner, computer screen and printer are all key components of this workflow and each speaks a different language. It is our job as the controller of the process to act as the interpreter between these devices (with a little help from software) to ensure that the correct colour information is communicated through the process.

You should not underestimate the fundamental importance of the post-processing stage in the production of fine prints. Many of the decisions you make here will ultimately decide how successful you will be at communicating with the viewer of the final print.

Fishing boat, Mondello, Sicily
By cropping in tight and avoiding all external references, I was able to concentrate on the wonderfully muted, pastel colours of the weathered paint on this fishing boat.

Photographer: Phil Malpas.

Technical summary: Canon EOS 5D with Canon 28–135mm f3.5–5.6 IS at 65mm, Aperture Priority, exposure 1/30 second at F16, ISO 50, no filtration.

Using RAW files and RAW conversion

All digital cameras provide the option to choose the file format that images are recorded and stored in. There are up to three options to choose from which are: **JPEG**, **TIFF** and **RAW**.

JPEGs are the most commonly used because they are a compressed version of the data captured by the camera, allowing more images to be stored on any given storage card. The problem with this is that the compression performed by the camera throws away some of the information captured, which can never be recovered. JPEG rearranges the image information into colour and detail, and compresses colour more than detail (because our eyes are more sensitive to detail making the compression less noticeable). Secondly, it sorts out the detail into fine and coarse areas and discards the fine detail first because our eyes are more sensitive to coarse detail.

TIFF is a universal format that is compatible with most image editing and viewing programs such as Adobe Photoshop. It can be compressed in a lossless way i.e. the discarded information can be recovered at a later date. The disadvantage is that TIFF files tend to be the largest of the three options available and therefore reduce the number of images that can be kept on the chosen storage devices.

Unlike the previous two options, RAW is not an acronym, but simply refers to the 'raw' unprocessed data that your camera captures. The biggest advantage of shooting RAW is that many of the camera settings that have been applied at the time of shooting can be amended at a later date (post processing) by using appropriate RAW processing software. For example, sharpening, white balance, exposure compensation, levels and colour adjustments can be undone and recalculated based on the RAW data. In addition, RAW retains 12-bits of available data (or 14-bits for the Canon ID MK III), which allows you to extract shadow and highlight detail that would have been lost in an 8-bit per channel TIFF file.

Adobe Camera RAW (ACR)

Adobe Camera RAW (ACR) is the Adobe offering in the post processing market. It comes free with the latest versions of Adobe Photoshop software and allows full manipulation and control of the majority of RAW formats. Using the Basic tab (shown here) the colour temperature, tint, saturation and vibrancy, amongst other things, can be adjusted.

Adobe Camera RAW (ACR) – the HSL/Grayscale tab

The HSL/Grayscale tab allows extremely fine adjustments to colour. The Hue, Saturation and Luminance of each of the 8 colour groups shown can be individually adjusted.

Canon Digital Photo Professional (DPP)

Canon Digital Photo Professional (DPP) comes free with newer Canon digital cameras. It supports RAW formats from all newer Canon models.

JPEG Joint Photographic Experts Group is the most commonly used digital file format, which can compress files to a fraction of their original size with little or no loss in quality

RAW the 'raw' unprocessed data that a camera captures

TIFF the Tagged Image File Format, a universal file format that is often used as the final format in the printing or publishing industries

Benefits of RAW files

Even though TIFF only retains 8-bits per channel (RGB) it will take up to twice as much storage as a 12-bit single channel RAW file. JPEG addresses this issue by using compression at the expense of quality. Consequently, RAW offers the best option – it retains the data captured by the camera and yet takes up less space than TIFF whilst offering you the ability to adjust your images in a number of ways.

One thing to remember is that, currently, RAW formats are not standardised. This means that each camera manufacturer, and even each camera model, will produce RAW files in a unique format. Any post-processing software you choose must be compatible with your camera make and model.

Phase One Capture One PRO post-processing software

Phase One's Capture One (PRO) was one of the first independent RAW workflow products to reach the market and will support many hundreds of RAW formats, including all the latest camera models.

Other major suppliers of RAW processing software are Nikon with Nikon Capture, which supports Nikon proprietary formats. Phase One's offering is called Capture One and was one of the first RAW workflow products on the market that was not linked to a major DSLR manufacturer. The main thing when choosing post-processing software is that you need to be sure it will support your particular camera's RAW format. This is particularly crucial if you have just purchased a brand new model as you may find that the non-proprietary software packages take some time to catch up with any new formats.

The advent and advancement of digital cameras has resulted in two major changes in the photographic world. Firstly, more and more people are taking pictures and secondly, those who are taking pictures are taking more and more of them. Once you own your digital storage there is no cost involved in taking pictures. Consequently photographers tend to shoot many more images than they did in the past. Most dedicated RAW processing software attempt to address this issue by implementing what is called workflow. The software designers recognise that we do not wish to spend hours sitting at the computer wading through thousands of images and we therefore need ways to simplify this task.

The first stage of any digital workflow can be described as the editing stage. The software package should help you to quickly download your images on to your computer and then sort through them, marking any that warrant further attention. In this way you can discount the less than perfect results and concentrate your effort on the successful shots.

Adobe Lightroom

Adobe Lightroom is a sophisticated workflow tool aimed solely at photographers. It will facilitate the processing of images through a number of stages: 1) Their organisation into a single library (which can exist in multiple physical locations). 2) Their development (conversion from RAW format as well as any of a myriad of image adjustments including complex colour adjust as shown here). 3) Their upload into a slide show for digital projection or immediate display on the World Wide Web. 4) Print production.

Correction stage in the digital workflow

The second and most important phase of the digital workflow is the correction stage. The best way to think of this is to regard your RAW file as a digital negative from which you can create a corrected file for printing or display. Any changes you make to the RAW file are stored separately from the original file and you can always go back to the RAW data and start again.

It is now possible to make any number of amendments to your image before saving the result into a format suitable for further processing, perhaps a TIFF file for exporting into Adobe Photoshop.

One of the key parameters that you may wish to adjust is the white balance. Digital cameras are not always successful at assessing the colour temperature of a light source and can often produce results that are either too warm or too cold. Provided we shoot our original image in RAW format, this is no longer an issue as we can override the settings made by the camera at the correction stage of our digital workflow.

There is one aspect of your picture taking technique that will help to ensure that you get good quality RAW files with the best potential for high quality conversions. When taking your shots it is vital to avoid over exposure. Over exposed pixels contain no information and no RAW processing software can create information from nothing. It is advisable to get into the habit of checking the exposure histogram at the taking stage and making sure that there are no clipped highlights. In high contrast situations, this may make the image look dark on the camera screen, but the shadows can always be brightened up later.

As long as you avoid overexposure you will end up with RAW files that can be adjusted for just about anything that you could have set on the camera at the taking stage – and some things that you couldn't! Standard adjustments will include exposure, brightness, contrast, saturation, hue, tint, curves, tonality and colour balance. Using these tools you can ensure that your images are fully saturated with rich colour and are correctly balanced with clean, neutral whites.

Shooting RAW files with your digital camera in conjunction with good RAW conversion software will allow you far greater control over the colour and quality of your images. You can keep the original RAW file as your 'digital negative' and amend it in as many different ways as you like, each time returning to the camera original.

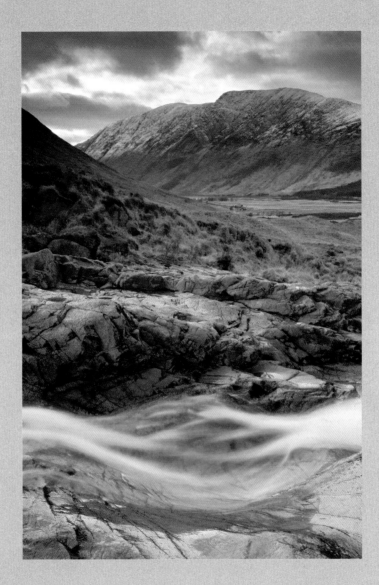

Glen Etive, Scotland

Using the correct setting for white balance in this image was crucial to its success. Too cool and I would lose the lovely warm colours in the grasses, too warm and I would lose the cold blue colour in the rushing water. By shooting in RAW mode I was able to forget this at the taking stage and concentrate on getting a good exposure. The precise white balance setting was then chosen during post processing.

Photographer: Phil Malpas.

Technical summary: Canon EOS 5D with Canon 17–40mm f4.0L USM at 37mm, Aperture Priority, exposure 1/2 second at F22, ISO 50, filtration: 0.6 NDGH.

Adobe Photoshop

It does not matter whether your digital images have come straight from your digital camera, or if they are scans of transparencies or negatives; once they are digital files that require attention they are effectively identical. There are many digital imaging software packages on the market, ranging from those that are free to download, through to top of the range packages costing as much as a digital SLR. It is widely agreed that Adobe Photoshop is the flagship package and is considered by many to be the industry standard. If you have access to Photoshop then that is fine, but many of the other packages available will have tools that allow you to complete similar adjustments to those covered in the following pages.

In general it is best to make amendments to digital images by using layers. This will allow you to easily undo single changes in a series of amendments. Adobe Photoshop offers many different options if you wish to change the colour of all, or part, of your image.

Added as part of the introduction for Photoshop Creative Suite (CS) are the array of Photo Filters that can be found under the Image/Adjust menu. In order to apply Photo Filters in a new layer choose: Layer > New Adjustment Layer > Photo Filter. The command attempts to create the effect that you would have achieved by placing a coloured filter over the lens when you took the photograph. There are filters of all the primary, secondary and some tertiary colours and, perhaps most useful of all, two warming and two cooling filters. When applying a filter its effect can be adjusted using the density slider which ranges from 0 to 100%.

The following five images show comparisons between the warming and cooling Photo Filters in Adobe Photoshop. You may find it interesting to compare the effects of these Photo Filters with the examples on pages 60 and 61 where colour temperature was applied digitally and on pages 94 and 95 where traditional filters were used on the camera.

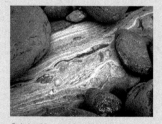 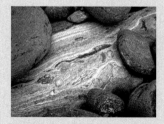 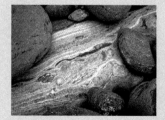

Original image (no filter) Photo Filter 81 (50%) Photo Filter 85 (50%)

An alternative to applying a Photo Filter to change the overall colour of your image is to manually apply single or multiple colour changes using the Colour Balance dialogue box. This command is also accessed from the Image/Adjust menu. The best way to make these amendments is in a new layer by choosing Layer > New Adjustment Layer > Colour Balance.

When selecting the Colour Balance option, a dialogue box appears that allows you to select either shadows, midtones or highlights to select the tonal range where you want your changes to take effect. You can then drag one of three sliders towards a colour you want to increase or away from a colour you want to decrease. The changes take effect between the RGB primaries and their complements so, for example, if you reduce blue you will increase yellow.

Adjusting the colour balance in Photoshop

Make sure that the Preview box is checked when making colour adjustments so that you can see the effect as you move the sliders. If you select Preserve Luminosity the tonal balance of the image will be maintained. The values above the sliders give numerical values to the changes you make.

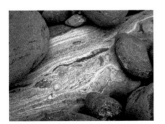

Photo Filter 80 (25%)

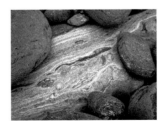

Photo Filter 82 (25%)

Bagh Steinigidh, Isle of Harris, Hebrides

The Photo Filters option in Adobe Photoshop allows you to simulate the effect you would have achieved if you had used one of the Wratten 80 series of filters at the taking stage.

Photographer: Phil Malpas.

Technical summary: Ebony SV45TE 4x5 field camera with Schneider Apo-Symmar 150mm f5.6 lens, exposure 1/2 second at F22.5, Fuji Velvia 50 rated at ISO 50, no filtration.

Adjusting colour

The ability to successfully adjust the colour of an image requires practice. In the traditional darkroom, printers were constantly looking at prints for colour casts and adjusting the filtration settings on their enlargers to remove them. One tool that was frequently used was called a ring-around where a series of exposures using different filtrations were made on the same piece of printing paper. The beauty of this approach was that comparisons could be made easily and one ring around was often enough to allow selection of the perfect filtration.

Adobe Photoshop has its own built in version of the ring-around, a command called Variations. Accessed through the Image > Adjustments menu, the Variations command will let you adjust colour although it is advisable to use this tool for information only. There are more subtle tools for actually adjusting colour such as Colour Balance and Selective Colour.

By far the most accurate tool for adjusting the colour of an image is the Selective Colour command. This command allows you to change the amount of each secondary colour that exists in any primary colour on a selective basis. For example, this tool would allow you to reduce yellow in the green component of your image without affecting the yellow in the blue or red components.

The Photoshop Variations command

The Variations command can give you an indication as to which colour adjustments you may have to apply. At the centre of the main section of the screen is your image without any adjustment surrounded by thumbnails showing what would happen if you add either a primary or secondary colour. You can also see the impact of darkening or lightening your image.

The Photoshop Selective Colour command

By using Selective Colour, you can change the amount of the CMYK colours in each of the primary colours, secondary colours or even whites, neutrals and blacks. With practice you can make very precise and subtle colour changes using this command.

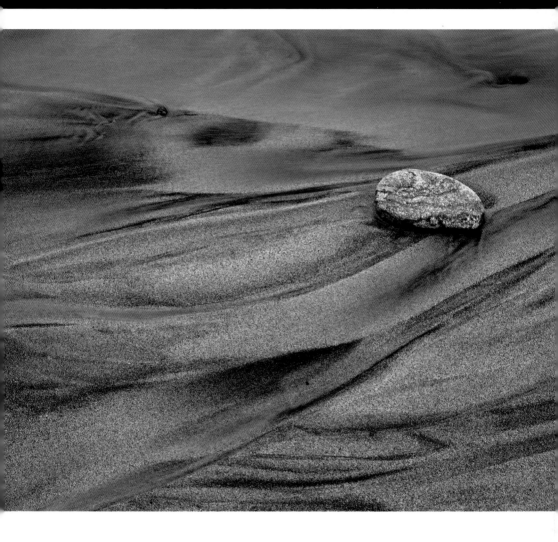

Dial Beag, Isle of Lewis, Hebrides

By using the various colour adjustment commands in Adobe Photoshop, the precise colours of the fantastic Hebridean sand with its filtered peat have been recalled by adjusting the scanned image file to the exact requirements.

Photographer: Phil Malpas.

Technical summary: Ebony SV45TE 4x5 field camera with Schneider Apo-Symmar 150mm f5.6 lens, exposure 1/4 second at F16.5, Fuji Velvia 50 rated at ISO 50, no filtration.

High contrast subjects

When photographing high contrast subjects digitally, there is always a decision to be made in relation to how to record both shadow and highlight detail. One option is to take a number of different exposures and merge them together in Adobe Photoshop, taking the highlights from one image, the shadows from another and perhaps the midtones from a third. The number of images you need to merge will depend on just how much contrast the subject contains. Normally three will be sufficient, but in extreme circumstances there is no reason why you cannot merge more. This method will allow you to maximise the colour saturation in your final image with full colour detail in both highlights and shadows.

A porch with a view

Wilson Tsoi adopted the multiple image technique in this superb shot of The Mukilteo Lighthouse, Washington, DC, USA. He shot three images, one exposed correctly and two others at plus and minus 1.3 stops. The over and under exposed images were dragged and dropped as new layers into the correctly exposed version. Using the Eraser and Lasso tools Wilson removed the over exposed highlights and the blocked out shadows, allowing the full detail from the other versions to show through. Once there was sufficient detail in both highlights and shadows, he adjusted the colour balance and saturation before flattening the image. Finally he copied the whole image into a new layer, applied Gaussian Blur at about 33% opacity, and then erased this new layer where detail was present, thus adding an attractive softened effect to the rest of the image.

Photographer: Wilson Tsoi.

Technical summary: Nikon D2X with Nikon 18mm lens, multiple exposure at various settings, no filtration.

Another interesting approach that can be taken is to use Adobe Photoshop to remove almost all the colour in an image. This is called desaturation, a technique that can be applied selectively to different parts of an image, thereby emphasising the parts of the image that retain their original colour.

Flamenco dancers, Havana, Cuba

In the original image, the background colours were distracting. By desaturating the majority of the image, whilst maintaining the flamenco teacher in colour, her role as leader of the group is emphasised.

Photographer: Phil Malpas.

Technical summary: Canon EOS 5D with Canon EF 100–400 f4.5–5.6L IS USM lens at 100mm, Aperture Priority, exposure 1/30 second at F5.6, ISO 800, Image Stabilisation on.

Merged image

Correct exposure

St Mary's Saxon church, Alton Barnes, Wiltshire

By taking both over and under exposed images alongside your correctly exposed image, you can maximise shadow and highlight detail (and therefore colour) later by merging them in Adobe Photoshop.

Photographer: Phil Malpas.

Technical summary: Canon EOS 5D with Canon 17–40mm f4.0L USM at 17mm, Aperture Priority, various exposures, ISO 50, no filtration.

One stop under exposed

One stop over exposed

Converting images to monochrome

There are many ways to convert a colour image to monochrome in Photoshop. As part of Creative Suite 3 (CS3) a new approach is available via the Image > Adjustments > Black & White command. Initially this command simply desaturates the image and the file remains in RGB mode. Subsequently it is possible to adjust the tonality (from dark to light) of each of the primary and secondary colours as they appear in the original colour image. For example, moving the blue slider to the left will darken any blue parts of the original image without affecting any other parts. There are a number of preset effects available as well as the ability to apply a toned effect using the Hue and Saturation sliders. For those who like to work in monochrome, this is an extremely powerful tool that will allow precise control over all tonal values.

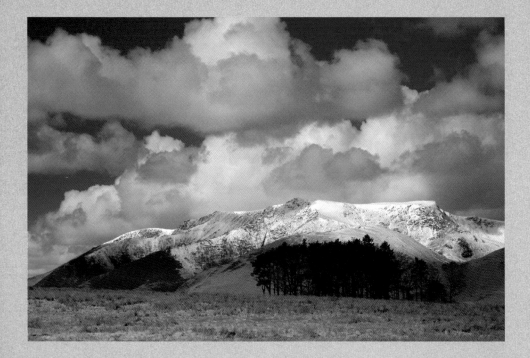

Original colour image of Blencathra, The Lake District

The initial colour image to be converted to monochrome.

Photographer: Phil Malpas.

Technical summary: Canon EOS 5D with Canon 17–40mm f4.0L USM at 17mm, Aperture Priority, exposure 1/15 second at F22, ISO 50, no filtration.

Image > Adjust > Black & White command in Photoshop CS3.

Various preset filter effects are available.

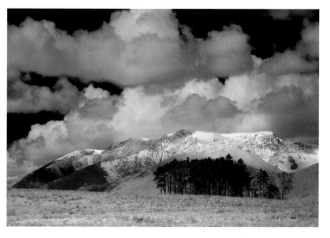

The resulting image using the 'High Contrast Red Filter' preset.

Toned monochrome

In the traditional darkroom, there are a number of available techniques for adding colour to monochrome photographs. Some of these are a by-product of improving the longevity of prints, where the silver is bleached away and replaced by something more permanent. Many old photographs are sepia-toned, giving them that familiar overall brown colour, and many other colours can be added to a traditional print by employing such toners as copper, gold and selenium. Toning prints in the traditional way is far from easy and requires a skilled practitioner if success is to be assured. Even experts would find it very difficult to exactly repeat a particular effect on multiple prints. Another downside to traditional toning is that many of the chemicals used in the darkroom are highly poisonous and quite difficult to obtain.

In the digital age it is possible to replicate traditional toned monochrome images without the chemicals or access to a darkroom.

Canon have introduced a function on their recently released digital cameras that allows the photographer to select a number of picture styles. These are predefined groups of parameters such as sharpness, saturation and contrast that enable the photographer to quickly select an approach to a particular subject. One of the settings under the Picture Style heading is Monochrome and once this is selected, other options are available to apply a particular colour tone to the monochrome image.

Locomotive bell, Australia Sugar Plantation, Cuba

Photographer: Phil Malpas.

Technical summary: Canon EOS 5D with Canon 17–40mm f4.0L USM at 30mm, Aperture Priority, exposure 1/100 second at F11, ISO 50, no filtration.

Normal monochrome

Blue tone

Green tone

Sepia tone

Purple tone

Adobe Photoshop and toned monochrome

An alternative method for creating toned monochrome images is to use Adobe Photoshop. Any image can be used either colour or monochrome, film or digital, but of course if the original is on film then a suitable scan will need to be made first. Once you have your digital image, open it in Photoshop and check the histogram by accessing Image > Adjustments > Levels. The image you have selected should have a good overall tonal range and contrast, which will show on the histogram as a solid black graph with no white gaps or large spikes. It should cover the entire width of the chart and be roughly the same height all the way across.

If your image is in colour, you will first need to convert it to monochrome. The first method for adding colour to the monochrome image is to use the Photo Filter adjustment. Access Image > Adjustments > Photo Filter and select Sepia from the drop-down menu. You can adjust the intensity of the change using the density slider at the bottom of the dialogue box.

Flamenco dancer (left) original (below) with photo filter sepia applied

By using the Photoshop Photo Filter command, you can add a sepia tone to monochrome images.

Photographer: Phil Malpas.

Technical summary: Canon EOS 5D with Canon EF 100–400 f4.5–5.6L IS USM lens at 250mm, Aperture Priority, exposure 1/60 second at F5.6, ISO 800, Image Stabilisation on.

More complex colours can be added using the **Duotone**, **Tritone** and **Quadtone** options. Once you have converted your image to greyscale, access the Duotone option using Image > Mode > Duotone. The drop-down menu has options for Duotone (two colours) Tritone (three colours) and Quadtone (four colours). It is normally the case that the first colour in your selection will be black, so a Duotone would normally be Black plus one other colour. It is worth experimenting though and it is possible to create some exciting effects using virtually any dark colour with an appropriate lighter one.

Adobe Duotone dialogue boxes

Once you have selected the duotone option there are a vast array of colours that you can choose to enhance your monochrome image.

There are a huge number of options available in Adobe Photoshop that enhance monochrome images using colour. In this image a duotone has been created by using black and one other colour. The image was then returned to RGB mode Image > Mode > RGB Color then saved as a TIFF file.

duotone a conversion of a monochrome image such that part of the tonal range is allocated to one colour and the rest to another

quadtone a conversion of a monochrome image such that parts of the tonal range are allocated to four different colours

tritone a conversion of a monochrome image such that parts of the tonal range are allocated to three different colours

Colour management

In order to produce a print from a digital photograph (either directly from a digital camera or scanned from film), the digital information has to travel through a workflow, which incorporates a number of physical devices (camera/scanner, screen and printer). Each device views individual colours differently and consequently changes the colour information associated with the original digital image. At the front end of the workflow is the digital camera or film scanner, which captures colour information in pixels, each of which has a red, green and blue component, known as its RGB value. The sensor that captures the original data is filtered using red, green and blue filters, the precise colour of which can vary from manufacturer to manufacturer and even from device to device. Once the image has been captured it is viewed on a screen, which has its own way of displaying all the colours in the original file. It is almost certain that there will be some colours captured on the camera or scanner that cannot be displayed accurately on the screen and so an alternative will be selected. Next is the printer, which will have yet another way of presenting the colours. The phrase that is used to describe colour in the above workflow is device-dependent.

If we wish to consistently make prints that match the original image colour then we need to employ a system that helps each device in the workflow successfully interpret the information it receives from its predecessor. Such a system is known as a colour management system (CMS), which has the aim of making colour device-independent.

There are a few key concepts that we need to understand when working in a colour-managed environment. Any device in the workflow is capable of rendering a finite set of colours known as its gamut. Any colour that a device cannot recreate is said to be 'out of gamut' and the CMS will need to substitute this colour for one that is within its range. The gamut of an individual device is a subset of a larger range of colours called a colour space. Different devices work in different colour spaces and each colour space is a subset of the visible spectrum.

Any (CMS) is actually a collection of software tools that allow the conversion of colour data between devices. One component of the CMS is the colour engine or colour matching method (CMM), which uses profiles to convert data from one device's colour space to the next by using an intermediate device-independent colour space. The International Colour Consortium (ICC) was established in 1993 to promote the standardisation of colour management across the industry and gives its name to device profiles. In a colour managed system, ICC profiles exist that can tell the CMM how each device in the workflow renders colour. When a particular colour for device A is out of gamut for device B, the CMM will perform an exercise called gamut mapping during which it will select an alternative based on a predefined set of rules.

The rules that the CMM uses to reallocate out of gamut colours are called rendering intents. There are a number of approaches to rendering, all of which captitalise on the fact that the human visual system is better at recognising colour relationships than colours in isolation. Consequently, if a colour is out of gamut it can be replaced without concern as long as its relationship with the surrounding colours is maintained.

For most of us who are interested in making prints from our own digital images, there is one key component in the digital workflow that we must address first – the monitor screen. As long as the screen shows a true representation of the colours in the image file, we can actually see the true colour of the image and adjust it as necessary. All computer screens are different and, left alone, will display a colour image differently. An image that appears to be perfectly displayed on one screen may look a completely different colour on another. The way to address this is to compare the way the screen displays a range of colours against a known standard, and create a profile that can compensate for any incorrectly displayed colours. This process is known as monitor calibration and in recent years has become a quick and affordable process. A fully profiled monitor screen will ensure that any image that is displayed correctly on that screen will also be displayed correctly on another calibrated screen.

Monitor calibration using the Colourvision Spyder2Pro

When setting up for calibration, the software indicates the precise position to locate the colourimeter.

During the calibration process, the software displays a series of colour swatches and the colourimeter compares the actual colour displayed with the expected colour. The software then creates an ICC profile for the screen, which compensates for any incorrect colours. The software will prompt the user on a regular basis to repeat the calibration process so that any minute changes in the monitor over time are corrected.

Digital printing

One of the first major areas of confusion in printing occurs regarding printer resolution and the relationship between digital file sizes and actual print sizes. If we take as an example a digital image that is 1,800 x 1,200 pixels. Assuming this is a full size image from a digital camera and hasn't been cropped, then firstly we can ascertain that it was taken on a 2.1 megapixel camera (because 1,800 x 1,200 equals 2,160,000 or 2.1 million pixels). The physical size of the image file is fixed and cannot change unless we choose to throw away some pixels or create some more through interpolation. When we open this image in Photoshop and go to the Image Size dialogue box, we can adjust how many **pixels per inch** we want the image to be sized at. For example, if we choose 300 pixels per inch then the physical size of the image when printed out would be 6 x 4 inches (1,800/300 x 1,200/300).

The Photoshop Image Size dialogue box

Left: The image from the 2.1 megapixel camera has the Resolution set to 300 PPI giving an actual size when printed of 6 x 4 inches. Note that the Resample Image box is unchecked.

Centre: The Resolution has been changed to 150 PPI. With the Resample Image box unchecked this has no physical impact on the file. In the Pixel Dimensions area at the top it remains at 1800 x 1200 pixels, which means that, if printed, the actual pixels will be spread out across a larger area (in this case 12 x 8 inches).

Right: The Resample Image box has been checked before the Resolution has been amended to 150 PPI. This has the effect of physically downsizing the image i.e. throwing away some of the original pixels. This can be clearly seen in the Pixel Dimensions area at the top.

The physical size should not be confused with the size that the image appears on the screen, because the screen resolution will be much lower than 300 pixels per inch and so the image will be shown with a magnification percentage. Under the View drop down menu, Photoshop gives a number of options regarding the size that the image will appear on the screen. By selecting Actual Pixels the image will be displayed at its full size of 1800 x 1200 meaning that it is unlikely that the whole image will be viewable. If Print Size is selected then the image will appear at the approximate size that it will appear when printed; in this case 6 x 4 inches. If we select Fit on Screen then Photoshop will show the image at the largest percentage size that can fit on to the screen and display this percentage at the top of the image window. So at 50% magnification the whole image will take up 900 x 600 pixels of the screen area. Changing the way the image is viewed does not affect the decision made in the Image Size dialogue box. The image is still sized at 300 pixels per inch and will still print at 6 x 4 inches.

The key thing to remember here is that the decision to size the image at 300 pixels per inch in the Image Size dialogue box refers to pixels per inch (PPI) where the pixels in question are those originally captured by the camera – of which there are 1800 x 1200 or 2.1 million.

This PPI setting selected is not the same as the '**dots per inch**' (DPI) option available in some printer drivers. These two terms are often confused, yet they refer to completely different things. They are not directly related and changing either PPI or DPI does not affect the other. DPI is actually a measure of the number of dots per inch the printer will place on the paper. Modern inkjet printers with multiple inks use a large number of dots to represent each pixel in the original image. The precise number will vary from printer to printer but if printing at 1,440 DPI, for example, only 240 PPI may be needed in the original file to create high quality photographic prints.

Print Quality settings in Epson print drivers

In the older print driver for the Epson 1290 printer the Print Quality setting was a choice between particular DPI settings (e.g. 360 DPI equals low quality, 1,440 DPI equals high quality).

In the newer driver software for the Epson 2400R, the reference to DPI has been removed entirely. Quality choices are now made based on a series of Quality Options from Draft to Best Photo although these do relate to specific DPI settings as follows : Draft = 180 DPI, Text = 360 DPI, Text & Image = 720 DPI, Photo = 1,440 DPI, Best Photo = 2,880 DPI.

dots per inch (DPI) the number of dots per inch of printed output

pixels per inch (PPI) the number of pixels per inch in a digital file

Colour in printing

The next major issue to address in order to avoid disappointing prints is colour. As mentioned in the previous section on colour management, the control of colour from image capture through to the printed output can be considered as a workflow through which the image passes. Each of the physical devices involved in this workflow (camera/scanner, screen, printer) will potentially have a different view of each of the colours the image contains. In order to address these device dependent views of colour it is important to provide sufficient information from one device to the next in order to get the best possible representation of actual colour.

From the printing perspective this usually involves the deployment of a suitable ICC profile. Many paper and printer manufacturers now provide ICC profiles free of charge, which can be downloaded and installed quite easily. These profiles are designed to ensure that each colour in the image colour space (e.g. Adobe RGB 1998 or sRGB) is associated with the best possible option from the gamut available to the printer/ink/media combination you intend to use. It is vital that you fully understand the settings that need to be made in both Photoshop and your print driver if these ICC profiles are to be implemented successfully. Unfortunately, every print driver will require different settings and so it is impossible to describe them all here. It is important, therefore, that you carefully read and understand your printer manual together with any instructions that came with the ICC profiles when you downloaded them.

An alternative is to have your own personal ICC profiles professionally created. A number of suppliers offer the option to download special 'target' files that you can print on your own printer at home. You send the resulting prints back to the supplier and they supply a custom ICC profile for your specific printer/ink/paper combination. It is important to realise that specific profiles will be needed for each printer/ink/paper combination you intend to use.

A final option might be to purchase specific profiling equipment that allows you to generate your own print profiles from your own target prints. These tend to use a specific piece of hardware called a spectrocolorimeter, which measures printed colours and compares them against known values.

One trap that is easy to fall into is to actually colour manage your image twice at the printing stage i.e. once from within the Photoshop Print dialogue box and once within the print driver. You must decide which approach you wish to adopt and this will depend on whether you intend to use custom ICC profiles. By setting the Colour Handling parameter to Let Printer Determine Colours (CS2) or Printer Manages Colours (CS3) you are telling Photoshop to hand over all responsibility for colour management of the document to the printer driver. If you set Colour Handling to Let Photoshop Determine Colours then it is vital that you switch off all colour management in your print driver. There is a third option for Colour Handling of No Colour Management, which you will need to use if you intend to create your own personal print profiles as discussed previously.

Photoshop CS2 Print With Preview

The Photoshop CS2 Print With
Preview dialogue box showing
the Colour Management section
with the all important Colour
Handling drop-down menu.

Photoshop CS3 Print

In the Photoshop CS3 version
the Print with Preview command
has been replaced with simply
Print. The options in the
redesigned dialogue box are
broadly the same.

In this section are featured images by photographers who, in my opinion, demonstrate a true mastery of colour. In each case I have described why I believe they have succeeded and which combination of techniques they have employed.

This is an exercise you can continue with your own favourite photographs. No matter how far you progress in your mastery of photography, you can always learn from the work of others. It is worth building up your own collection of work, perhaps from books or magazines, and in each case analysing why you think the images are successful. When looking at colour images, the criteria by which you judge this success may well be those covered in the previous sections of this book.

Carry out a careful analysis of the techniques used in your favourite work. How has colour been used compositionally? Which colours have been selected and how do they work together? How does the photograph make you feel and why? What specific techniques do you think the photographer employed? What lighting was used? When and where was the image made, and how did all this affect the resulting colours? By analysing your favourite photographs in this way, you will soon build approaches that work best for you, and develop your own mastery of colour.

Water Channel, Zion NP, USA

By cropping in tight and making sure that no unnecessary elements crept into my composition, I was able to concentrate the viewer's attention on this spectacular red rock in Zion NP.

Photographer: Phil Malpas.

Technical summary: Ebony SV45TE 4x5 field camera with Nikon Nikkor M 300mm f9 lens, exposure 4 seconds at F22, Fuji Velvia 50 rated at ISO 50, no filtration.

William Lesch

Based in Tuscon, Arizona, USA, William Lesch has built an outstanding reputation as a fine art photographer specialising in 'light painting' techniques.

These finely crafted images involve many hours of planning and implementation, which result in spectacularly colourful images, examples of which are shown here. Both these images were shot on a large-format 4x5 inch Sinar camera with a wide-angle 75mm Schneider Super-Angulon lens, using Fuji Provia film.

Exposure calculation for William's images is extremely technical. The initial exposure is of short duration to capture the daylight components of the image, which is then followed by subsequent exposures in darkness that may total up to two hours. During these subsequent exposures, William 'paints' his subject with light using coloured gels supplied by Roscoe. Each colour is carefully added to build up the overall exposure and add the wonderful, fantasy colours whilst maintaining correct exposure throughout the image. No post-processing is performed digitally – these are straight images completed entirely 'in-camera'.

The light painting technique requires careful planning to ensure that the subject is evenly lit and correctly exposed during the extremely long exposure times. A clear visualisation of the desired result is imperative, including the planning of the direction of the illumination to avoid unrealistic shadow effects. An obvious drawback of this approach is that results are difficult to predict and any mistakes can ruin many hours of effort. To achieve spectacular images like these requires significant practice and experience, but the effort is surely worth it when results like William's wonderful images can be achieved.

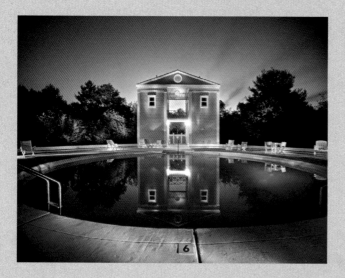

1 (left)

Photographer: William Lesch.

Technical summary: Sinar 4x5 studio camera, with Schneider Super-Angulon 75mm lens, multiple exposures over several hours, Fuji Provia 100, no filtration.

4 (facing opposite)

Photographer: William Lesch.

Technical summary: Sinar 4x5 studio camera, with Schneider Super-Angulon 75mm lens, multiple exposures over several hours, Fuji Provia 100, no filtration.

Joe Cornish

Shot at Dunraven Bay in South Wales, Joe's image of the wave-cut platform is a true masterpiece and one of my favourite images of all time. For the visually uneducated, it is easy to take such sublime beauty for granted. The digital revolution has brought a certain quality of image-making within reach of all of us and our modern day, throw-away society encourages us to consume images with hardly a second glance. Those of us who have invested time and effort in our own personal pursuit of the illusive masterful image will however, be very aware that such perfection does not come easily.

The key fact here is that the subject would not have appeared anything like this to the naked eye. The human visual system compensates instantly through the process known as colour constancy for light sources that are a different colour to what we expect. In this case the grey rocks are lit only by the blue sky above, a light source with a colour temperature far in excess of the 5,500 degrees kelvin expected by the film. The rocks would still have appeared to be grey as Joe contemplated his composition, yet he was fully aware that they would not appear that way to the film.

The main subject is in open shade, but the cliff face beyond the composition is in full early sunlight. This warm yellow light is reflected in the pools of water giving a perfect balance between the two complementary colours, thereby maximising the colour contrast. The south facing cliffs will only receive direct light at this time of day for a few mid-winter weeks and add to this the planning required for the tidal variations, and it starts to become clear that this image required all of Joe's considerable knowledge and experience to achieve.

In his book *First Light*, Joe magnanimously admits that on his first attempt he did employ an 81B warming filter to compensate for the high colour temperature. He says that: 'Although it took time to tune in, by the second day I had figured out what I wanted to do. Shooting unfiltered, I was able to combine the two complementary colours, blue and yellow, which helped dramatise the curved, tide-beaten surfaces of the rock platform'.

If you wish to capture such images an intimate knowledge of your equipment and how it will react to different circumstances, even when your eyes are telling you something completely different, is a vital prerequisite.

Contours in blue

Photographer: Joe Cornish.

Technical summary: Ebony SW45 4x5 field camera with extension back, Fujinon T 300mm, exposure 1 second at F22, Fuji Velvia ISO 50, no filtration.

Wilson Tsoi

When I first saw Wilson's photographs, I was immediately impressed by the depth and strength of colour exhibited in his work. These images are part of a project he has been working on to document downtown Seattle using digital techniques. They are three very different compositions of the beautiful Space Needle taken from highly imaginative viewpoints. In order to capture saturated colour throughout the contrast range Wilson often takes a number of images at different exposures and merges these together in Adobe Photoshop. This allows him to capture full colour in both highlight and shadow areas, even when the subject itself is beyond the dynamic range of his camera. If he finds himself in a situation in which the multiple exposure technique isn't possible, he will create additional versions of the original image either at the RAW conversion stage or in Photoshop. These additional copies will include either exposure or white balance adjustments, which can then be layered and selectively erased to create the final image. Wilson has developed these techniques to the point where he can produce wonderful, bold, colourful compositions like these even when the lighting conditions are extremely challenging.

Up on the roof

Photographer: Wilson Tsoi.

Technical summary: Nikon D2X with 105 Nikon lens, exposure 5 seconds at F11, no filtration.

Funny flower

Photographer: Wilson Tsoi.

Technical summary: Canon Powershot A80, no other details recorded.

Standing tall

Photographer: Wilson Tsoi.

Technical summary: Canon G3, exposure 8 seconds at F8, no other details recorded.

Sue Bishop

Sue Bishop's highly romantic floral studies emanate a sense of peace and tranquillity, with their carefully structured viewpoints and skillful use of differential focusing. Her work is characterised by strong, bold colours that grant the viewer a window into a fantasy world that only close-up photography can provide. In both of these images, Sue has carefully selected the small areas of the image that need to be sharp in order to allow the colours within each composition to dominate. It is the simplicity of composition that allows the colour to shine through, and the carefully chosen viewpoint that limits the colour palette to only a few selected hues. These timeless images portray the true wonder of mother nature at this most intimate level.

Yellow Tulip I (above)

Photographer: Sue Bishop.

Technical summary: Nikon F100, 200mm Micro-Nikkor, f4, Fuji Velvia 50, filtration: 81B.

Waterlily II (left)

Photographer: Sue Bishop.

Technical summary: Nikon F100, 55mm Micro-Nikkor with extension tubes, F2.8, Fuji Velvia 50, no filtration.

Steve McCurry

Steve McCurry's work is amongst the most recognised of its kind in the world today. His photography hit the headlines when, disguised as a native, he managed to smuggle himself into Afghanistan just before the Russian invasion. The images he brought back were to gain recognition throughout the world as some of the first to expose the horror and humanitarian stories behind the conflict occurring there.

Steve's work consistently exhibits a strong and powerful use of colour, which is a key component in his search for the 'essence of human struggle and joy', elements that are clearly illustrated in the image shown. Here the use of colour is truly impressive, a completely warm palette to support the feelings of joy, happiness and sheer excitement that this group are experiencing. During the Holi Festival, traditionally coloured powders are thrown over friends and passers by to represent energy, life and joy. In particular our eyes are drawn to the central figure whose spectacular smile is symbolic of the surrounding celebration.

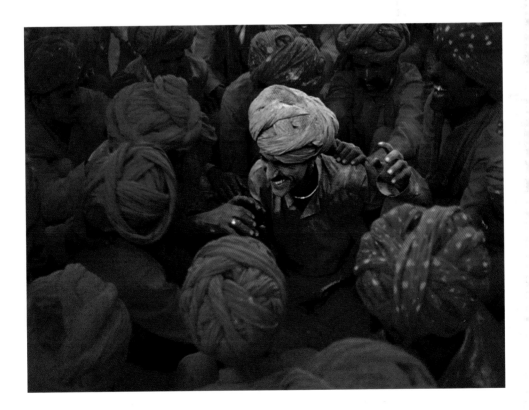

Villagers participating in the Holi Festival, Rajasthan, India 1996

Photographer: Steve McCurry.

Technical summary: Nikon N90, with 50mm lens, exposure 1/125 second at F2.8, ISO 100.

Conclusion

When Kodak introduced Kodachrome, the first 'modern' three-layer colour film in 1935, they completely revolutionised photography. Suddenly a whole new world of images was available, which enabled photographers to celebrate the glory of light as never before.

Light is, of course, the fundamental component in the photographic process and the human visual system has evolved to generate a psychological response to its varying wavelengths that we know as colour. Colour is therefore a fundamental property of light and in order to create inspirational colour photographs we must develop an intimate relationship with it. It is also vital that we understand the differences between the way that we see the world and the way that film or the digital sensor will record it.

Classical colour theory can teach us much about the relationships between colours and the type of effect different colour combinations can promote. It is also important that we remain aware of both psychological and cultural influences and the way they might 'colour' the viewer's judgement. Armed with these analysis tools we can observe the world around us in a new light. We are bombarded with images in our daily lives, each of which has been selected to try and promote a particular response from us. Study these images carefully and form your own opinions as to the reasons for their success or failure.

When putting this theoretical knowledge into practice, filtration is a key tool in the photographer's armoury. Use your filters to correct for variances in colour temperature or to balance contrast to enable the capture of full colour information. Buy the highest quality filters that your budget allows and experiment with them all the time. Keep detailed notes so that you can understand and repeat your successes whilst avoiding any approaches that don't work so well.

The introduction of Kodachrome in 1935 was a major milestone in photographic history. In my opinion, however, it was fairly minor compared to the digital revolution we find ourselves immersed in today. Digital technology has provided us with an unprecedented level of control over our image-making and in particular the colours of individual components within those images. It is important that we generate a sound knowledge of this new technology and how we can exploit it to our advantage, whilst still recognising that there may be occasions when good old-fashioned film should be the medium of choice.

Most importantly you should develop your own intimate relationship with light and colour, through constant observation of the world around you. Study both in all their glory, learn to love them dearly and I am certain that your personal photographic journey will rise to a new level.

Purple car, Trinidad, Cuba

My first reaction on seeing this car was to photograph it in its environment showing the cobbled Trinidad streets and colourful buildings around. As is often the case I gradually refined my ideas and ended up completely filling the frame with the spectacular purple colour.

Photographer: Phil Malpas.

Technical summary: Canon EOS 5D with Canon EF 100–400 f4.5–5.6L IS USM lens at 400mm, Aperture Priority, exposure 1/500 second at F5.6, ISO 50, no filtration.

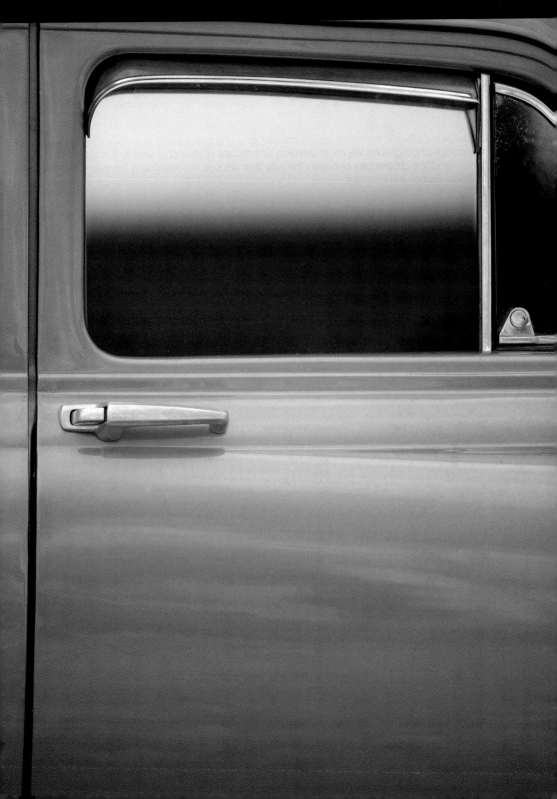

Absolute zero
Minus 273 degrees Celsius, a theoretical temperature at which objects possess no heat, equal to zero degrees on the Kelvin scale.

Analogous colours
Colours that are next to each other on the colour wheel.

Anomalous trichromat
A person whose vision is based on three colours, one of which is defective.

Anti-aliasing filter
Used in digital cameras to blur fine detail so that colours can be captured accurately.

Bayer pattern
The most common pattern of filters that cover the sensor in a digital camera.

Calibration
The process of returning a device to a known set of colour conditions.

CC filters
Colour compensating filters that are used to match the colour of a light source to that expected by the film.

Circular filter
A filter that has a particular thread size, which is designed to fit a certain size of lens.

Colour constancy
The tendency for the human visual system to make colour appear the same under different light sources.

Colour contrast
Colours on opposite sides of the colour wheel exhibit the maximum colour contrast.

Colour correction filter/colour conversion filters
The Wratten 80 series of filters that are used to convert a light source of one colour temperature to that expected by the film.

Colour engine
A software component that uses profiles to convert data from one device's colour space to the next by using an intermediate device-independent colour space.

Colour filter array (CFA)
The mosaic of colour filters that cover the sensor in a digital camera.

Colour harmony
Adjacent colours on the colour wheel are the most harmonious.

Colour management
The process by which we ensure that different devices can communicate effectively and accurately about colour, such that colour remains consistent.

Colour space
A defined subset of all the available colours in the visible spectrum.

Colour temperature
A numerical value based on the Kelvin scale, used to define light of a particular colour.

Colour temperature meter
A meter that measures the colour of a light source in kelvins.

Complementary colour
Any two colours on opposite sides of the colour wheel.

Cones
Cells in the retina that only capture colour information.

Cornea
The transparent covering at the front of the eye that protects the iris and lens.

Daylight balanced
The term applied to films that are designed for use in normal daylight conditions.

Demosaicing
The process that estimates the red, green or blue values that a digital camera does not capture through its colour filter array.

Deuteranopia
A form of colour blindness characterised by an insensitivity to green.

Device-dependent
The fact that the individual components of a digital workflow, e.g. camera, scanner, screen, printer etc. all see colour differently.

Dichromat
A person whose vision is based only on two of the three primary colours.

Dots per inch (DPI)
The number of dots per inch of printed output.

Dye coupling
The technology used to substitute coloured dyes for activated silver halides during film development.

Electromagnetic spectrum
The spectrum that describes radiation of varying wavelengths from radio waves to gamma waves of which visible light is just a small part.

Electron-volt
A standard unit of energy equal to the energy acquired by an electron accelerating through a potential difference of one volt.

Far infrared
Electromagnetic radiation with wavelengths between 30,000 and 100,000 nanometres.

Filter factor
The amount of additional exposure required to compensate for the use of a particular filter.

Frequency
The number of waves that pass a given point in a given time interval.

Gamma rays
All radiation with an energy level greater than 100,000 electron volts.

Gamut
The full range of colours supported by a specific device or profile.

Graduated filter
A filter that is partly clear and partly coloured, used to apply either a false colour or neutral density to part of an image.

Hard filters
Graduated filters in which the area of graduation extends across a smaller portion of the filter.

Hertz/cycles per second
The standard measurement of frequency; the number of waves passing a given point in a given time frame.

Hot mirror
A small filter inserted in some digital cameras to block infrared light from reaching the sensor.

Hue
Any colour, such as a red, green or blue, which is determined by the dominant wavelength of light.

Infrared/beyond red
Invisible radiation with a wavelength longer than 750nm but shorter than 1mm of microwave radiation.

International Colour Consortium (ICC)
The organisation set up to promote and encourage the standardisation of colour management across the industry that gives its name to device profiles.

International System of Units (SI)
A network of international agreements that standardises various measurements based on the metric approach.

Interpolation
Adding data to the captured image in digital photography to either create a full colour image or increase the image size.

Iris
The human equivalent of the aperture that controls brightness and gives the eye its colour.

JPEG
Joint Photographic Experts Group is the most commonly used digital file format, which can compress files to a fraction of their original size with little or no loss in quality.

Kelvin scale
The temperature scale that begins at absolute zero.

Kodak Wratten Series
A naming standard for photographic filters that takes its name from Frederick Wratten.

Lens (for eye)
The component of the eye that focuses incoming light rays on to the retina.

Limbic system
A group of interconnected brain structures that contribute to the control of emotion, memory and behaviour.

Metamerism
The ability of the human visual system to see things as being constantly coloured under varying coloured light sources.

Microwaves
Electromagnetic radiation with wavelengths between 1mm and 10cm.

Mid infrared
Electromagnetic radiation with wavelengths between 3,000 and 30,000 nanometres.

Minus blue
Another description of yellow (a mixture of red and green), which contains no blue.

Mired
Micro reciprocal degrees, used to measure the amount of change a particular colour correction filter will make to a specific light source.

Mired shift
The amount of change in colour caused by a particular filter – measured in mireds.

Monochromacy
A rare form of complete colour blindness where colours can only be distinguished by their brightness.

Monochrome film
More commonly known as black-and-white film.

Nanometre
One thousand millionth of a metre or 10^{-9} metres; a measure used in relation to the wavelength of light.

Near infrared
Electromagnetic radiation with wavelengths between 750 and 3,000 nanometres.

Neutral density
Used in relation to filters that contain no colour. These filters are used purely to affect exposure and will not produce a colour cast.

Noise
Statistical variations in the response to light by a digital camera sensor that result in a degradation of the image.

Orthochromatic
Sensitive to all colours except red.

Panchromatic
Sensitive to all colours of the visible spectrum.

Photographic daylight
A mixture of direct sun and open blue sky illumination, as found in Washington, DC, USA on a typical clear day between the hours of 10am and 4pm.

Photosite
An alternative name for a single photo receptor on a digital camera sensor, commonly known as a pixel.

Pixels per inch (PPI)
The number of pixels per inch in a digital file.

Glossary ⇨

Polarisation axis
The alignment of molecules in a polarising filter.

Polarising filter
A specialised filter that has the ability to block partially polarised light. It has the effect of darkening skies and reducing reflections.

Primary colours
One of the key colours that can theoretically be used to generate all other colours.

Protanopia
A form of colour blindness characterised by a defective perception of red, often confusing it with green or bluish green.

RAW files
Digital files that consist of the unprocessed data.

Retina
The rear interior surface of the eye that holds the rod and cone cells and connects to the optic nerve.

Rods
Cells in the retina that only capture contrast (or black and white) information.

Saturation
The vividness of a particular hue, or its difference from grey at a chosen brightness.

Sclera
The membrane that contains the eye and maintains its shape whilst acting as an anchor for the muscles that control eye movement.

Secondary colours
The complementary colours to the primary colours.

Shades
Colours that are mixed with black (or made darker) and are no longer of pure hue.

Soft filters
Graduated filters in which the area of graduation extends across a larger portion of the filter.

Split complementary colour scheme
A colour scheme using three colours that includes a harmonious colour.

Step-up rings
Adapters that allow the fitting of an oversized filter to the front of a smaller lens.

System filters
Photographic filters where a range of filters will fit into a single filter holder, which can then be used to cover a variety of lenses.

Tertiary colours
There are 12 colours on the colour wheel, three are primary, three are secondary and the remaining six are tertiary.

Tetradic
A colour scheme that utilises two sets of complementary colours.

TIFF
The Tagged Image File Format, a universal file format that is often used as the final format in the printing or publishing industries.

Tints
When colours are mixed with white (or made lighter) they are no longer of pure hue and are known as tints.

Triadic
A colour scheme that utilises three colours that are equally spaced around the colour wheel.

Trichromat
A person with normal vision that is based on all three primary colours.

Tritanopia
A form of colour blindness characterised by an inability to distinguish blue and yellow.

TTL (through-the-lens) metering system
The ability of some cameras to take meter readings through the lens.

Tungsten balanced
The term applied to films that are designed to produce the effect of daylight illumination under tungsten lighting.

Ultraviolet/UV
Radiation lying outside the visible range with wavelengths shorter than light but longer than X rays.

Value
The lightness or brightness of a particular hue.

Vignetting
A problem that occurs with wide-angled lenses when the filter is visible in the final image.

Visible spectrum of light
The small portion at the centre of the electromagnetic spectrum containing radiation with wavelengths visible to humans.

Warm up filters
The Wratten 81 series of filters, which reduce the apparent colour temperature.

Wavelength
The distance between one peak or trough on a wave and the next corresponding peak or trough.

White balance
A term used in digital photography that relates to the camera's attempts to remove colour casts due to the colour of the light source.

X-rays
Electromagnetic radiation with energy between 100 and 100,000 electron volts.

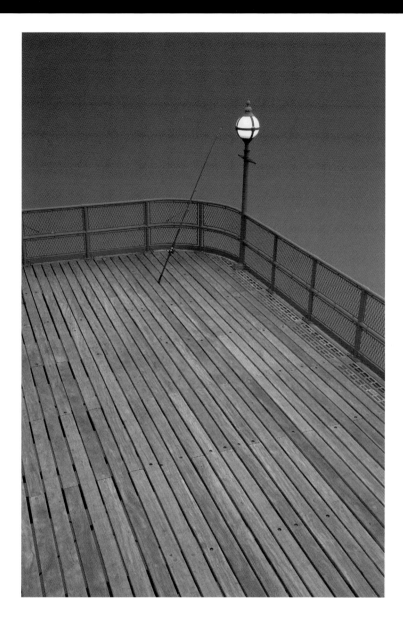

Clevedon Pier

This image taken at the end of a dull, overcast day has a very muted colour palette that supports the loneliness suggested by the single, untended fishing rod. If the same image was taken on a bright sunny day the emotional content would be lost.

Photographer: Phil Malpas.

Technical summary: Canon EOS 5D with Canon 17–40mm f4.0L USM at 40mm, Aperture Priority, exposure 2 seconds at F14, ISO 50, no filtration.

Acknowledgements

I would first like to express my gratitude to Mr Brian Walker of The Blackthorn School of Photography in Cricklade Wiltshire for teaching me the Zone System and encouraging me to pursue my dreams.

I must also thank Charlie Waite for his help and guidance in all matters and for showing trust in me by allowing me to run tours around the world for his company Light and Land Photographic Holidays.

I have learned so much from the three other members of the CUBS Photographic Society, Clive Minnitt, David Ward and Joe Cornish (not all of it about photography) and must particularly acknowledge my partner in crime Clive who has helped me through many a sticky situation during our travels together.

A big thank you to my partner Rachel for not getting mad at me each time I explain that I am off travelling again, and also my Mum and Dad for believing in my early enthusiasm and bank rolling my first steps on the photographic ladder.

A final thank you to all at AVA Publishing, in particular Lucy Bryan who has been a constant source of support and encouragement.

Contacts

Sue Bishop	www.suebishop.co.uk
Joe Cornish	www.joecornish.com
William Lesch	www.leschphotography.com
Phil Malpas	www.philmalpas.com
Steve McCurry	www.stevemccurry.com
Clive Minnitt	www.minnitt.com
Jean-Sébastien Monzani	www.jsmonzani.com
Frantisek Staud	www.phototravels.net
Guido Steenkamp	www.zeitkonserven.de
Mellik Tamás	www.melliktamas.com
Wilson Tsoi	www.photo.net/photos/wilsontsoi
Pete Turner	www.peteturner.com
David Ward	www.davidwardphoto.co.uk
Ilona Wellmann	www.IlonaWellmann.meinatelier.de/www.trevillion.com